GOINGS ON ABOUT TOWN

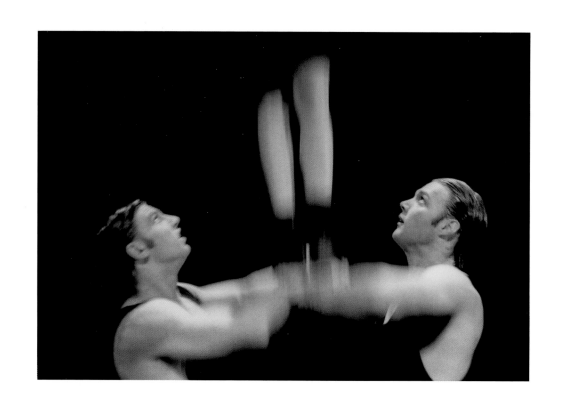

Sylvia Plachy

GOINGS ON ABOUT TOWN

PHOTOGRAPHS FOR THE NEW YORKER

FOREWORD: MARK SINGER • AFTERWORD: ELISABETH BIONDI

aperture · THE NEW YORKER

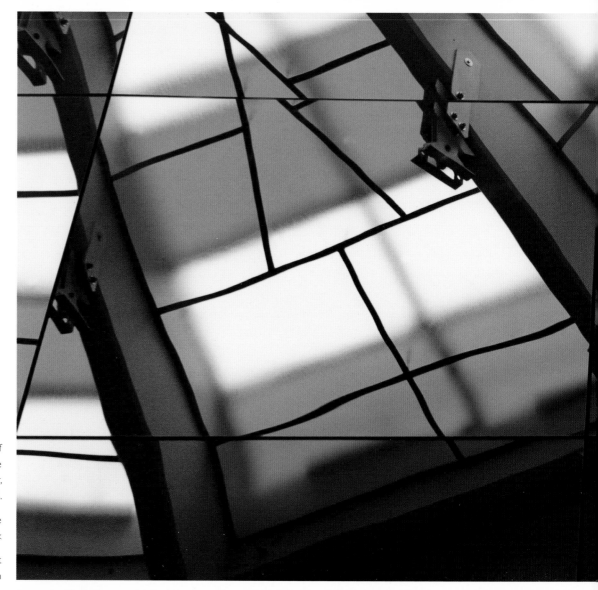

All photographs, with the exception of
the portrait of André Kertész, were
made on assignment for *The New Yorker*,
primarily during 2005 and 2006.

Frontispiece: Quebec's Cirque Éloize at the
New Jersey Performing Arts Center, Newark

Right: Daniel Buren's *Eye of the Storm*, in situ at
the Solomon R. Guggenheim Museum

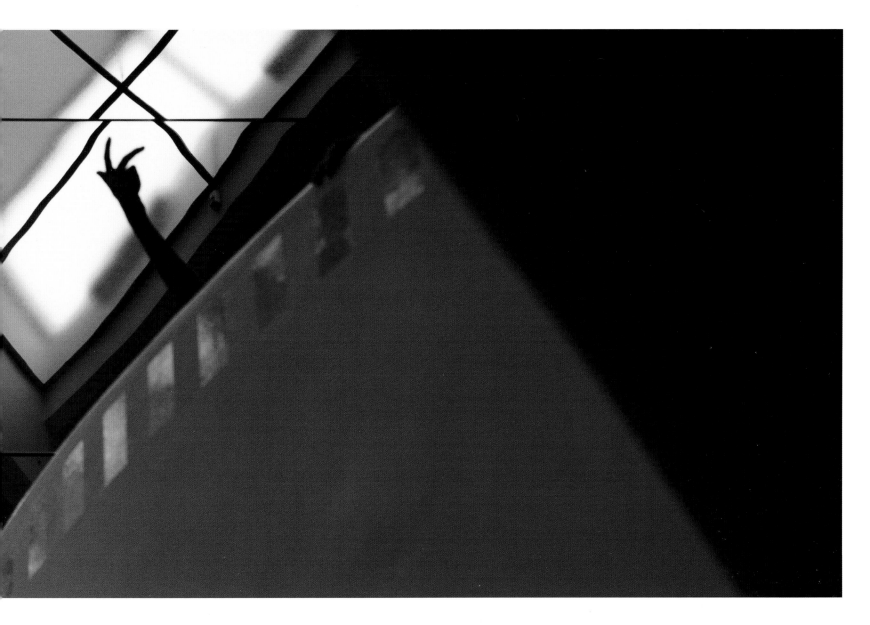

FOREWORD BY MARK SINGER

Among the pleasures evoked by Sylvia Plachy's work across the years—along with the pleasure of often watching Sylvia *at* work—has been my awareness that I don't possess, or wish to possess, even a dim grasp of how she achieves the magical effects that unassumingly radiate from her photographs. All I've learned, really, is that no creative person whose process I've observed has struck me as being more dedicated to completing the task at hand.

There's a labor-intensive physicality to Sylvia's method, coupled with—as a career's worth of evidence makes plain—a hyper-alertness to every sensory stimulus within range. For many artists, certainly, relentlessness and deliberation, properly applied, yield the illusion of effortlessness. In Sylvia's case, she approaches her subjects with a peculiar mixture of doggedness and dreaminess, calculation combined with faith in the unforeseen.

She both does and doesn't travel light. Wherever she goes, she makes her way without either an assistant or a cumbersome ego—with just a knapsack or a shoulder bag sagging with equipment. She raises the camera, lowers the camera, circles the perimeter, shoots, retreats, shoots shoots shoots. Her appearance is self-effacing, vaguely bohemian-hip. A prototypical downtowner or Upper West Sider, you figure (though she's actually lived for more than thirty years in, what's it to you, Queens), with a lambent smile that entirely disarms. Stalking without threatening, she nimbly pursues what only she, for the moment, can envision. In that instant, she conjures; at some future moment, we will savor.

In 2005, a reconception and redesign of *The New Yorker*'s Goings On About Town department (GOAT, per in-house parlance) took place. Each week's dozen or so pages of cultural listings, it was decided, would now open with a photograph, and Sylvia Plachy was the obvious first choice for this assignment. The goal was to depict, behind the scenes or just below the surface, the flow and tempo of a city populated by creatures (by no means exclusively human creatures, it would turn out) who tirelessly perform, make art, take risks, plot spectacles, stir epiphanies. Above all, the desire was to witness and capture, with sensibility and omnivorous curiosity, particular fellow-citizens in the act of rendering life more interesting for the rest of us. For more than a year, Sylvia Plachy, an ideal fellow-citizen, had a byline in every issue of *The New Yorker*.

Given that provenance, the work gathered here is not easy to classify—an inadvertent photo-essay, perhaps. It comprises eighty-one photographs winnowed from the thousands she took during her extended GOAT endeavor, plus one astonishing grace note, a portrait of André Kertész, her mentor and honorary grandfather, who called her ("affectionately," she insists) *taknyos*—"snotnose," in their native Hungarian. Sylvia herself likes to think of the whole as a song, each image a phrase in a melody or a sentence in a lyrical prose poem. And why not.

Often, the logistics are complicated. How, for instance, do you herald Cirque Éloize, a Canadian troupe that will be featured in June and July at the New Victory Theater, in Manhattan? You find out that they're

performing in March in Newark, New Jersey, you go there, you come home with an image, shot from backstage, of a bald juggler in a spotlight. Though, naturally, not just any juggler. Is that a woman or a transvestite? Those levitating furry things couldn't be puppies, could they? Please. They're *wigs*—a wigless wig juggler, juxtaposed, on the facing page, with three manta rays at the New York Aquarium, in Coney Island, gliding like fighter planes in formation. The luminous nimbus at the center of the juggling scene in Newark corresponds with a comet-tail of light—a flash reflected by the aquarium glass? a heavenly emanation?—that somehow materialized when Sylvia clicked the shutter in Brooklyn. Take away the manta rays and what remains might well be an abstract painting with an echo of Monet: water, light, silhouette. Not an outcome you anticipate three months in advance.

Years ago, in Shreveport, Louisiana, I was a passenger in a rental car, Sylvia was behind the wheel, and we were rushing—I can't recall why—to a riverboat casino when the vehicle became briefly airborne. Afterward, she cheerfully rejected my suggestion that maybe she should stick with subways and taxis. As it is, she travels more widely (pick a continent, pick a country) than anyone I know. Which makes it no coincidence, I suppose, that with very few exceptions—a still life shot on a movie set; the Morgan Library under renovation—someone or some living thing moves through each of these photographs. Staying in motion, presumably, is one of Sylvia's intuitive strategies for making her own luck. Another moment in Brooklyn:

Little League opening day in Prospect Park, six short-legged boys running downhill, bare trees in the distance, the foreground no more focused than the background, nor should it be, as any former child who can recall the quivering anticipation of an opening day will tell you. "I was running after them," Sylvia told me. "They were excited and I got excited from them being excited."

One day not long ago, as Sylvia and I perused the galleys of this book, I posed a few technical questions. Some images, especially those taken with a panoramic camera, had a deliberately gauzy texture, but what about the portrait of the musical Cagle family performing in the subway? "No," she said. "It's just blurry." Of the snakelike strands of light that dance through the image of Amadou et Mariam at Joe's Pub: "I didn't do it. It was God's gift. I make mistakes. The camera breaks. The shutter stayed open forever. You've got to get lucky with that—otherwise the squiggles don't make sense. They go with the music. You can feel the music, but actually it's me shaking."

I'd done a tally and noticed that about three-quarters of the pictures were interior shots. Where, I wondered, did she prefer to work? "I like where there's light. I usually prefer outside because I see better." She paused, then added, "But I like to go inside even if I'm outside. Even if I'm looking at animals at the zoo, I want to go into the bushes, into their minds. Whatever's going on, I want to see what they feel." And because she can, eventually, of course—thank you very much—so can we.

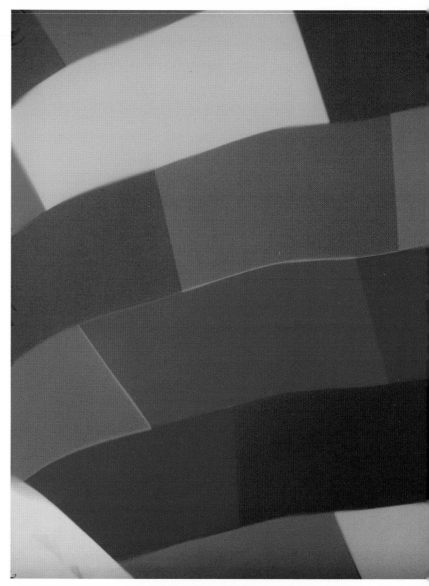

Sol LeWitt's rooftop installation
at the Metropolitan Museum of Art

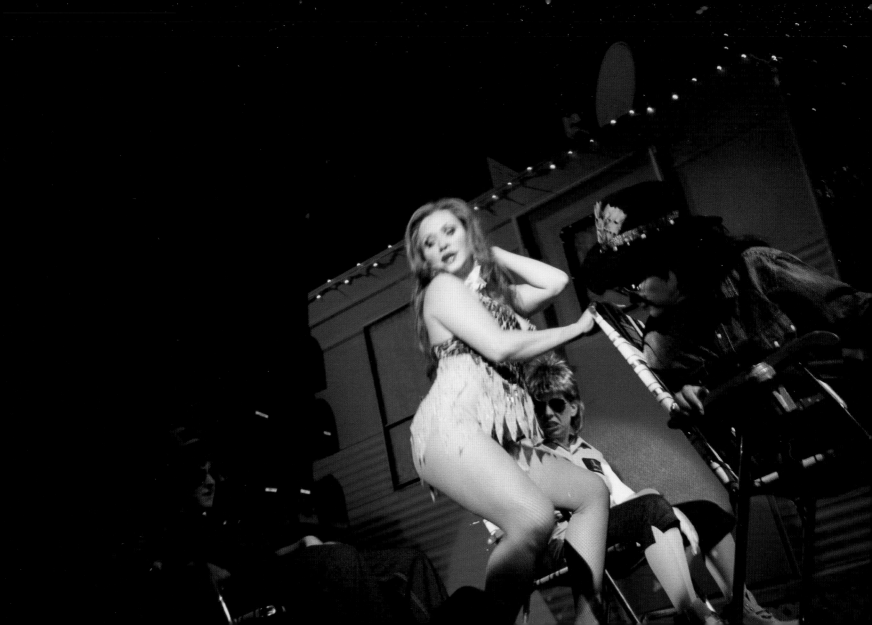

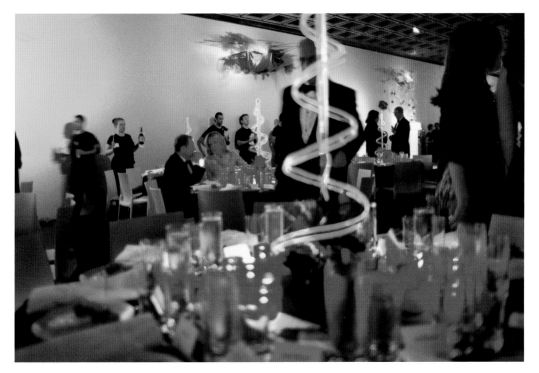

Opposite: *The Great American Trailer Park Musical*

Above: Richard Tuttle's *Art Into Life* at the Whitney Museum of American Art

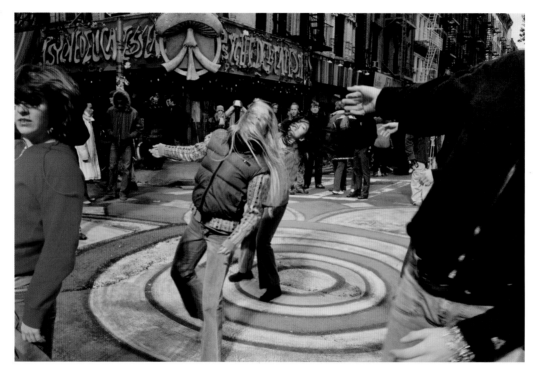

Above: Filming Julie Taymor's *Across the Universe*

Opposite: Children playing at a Celebrate Brooklyn! concert

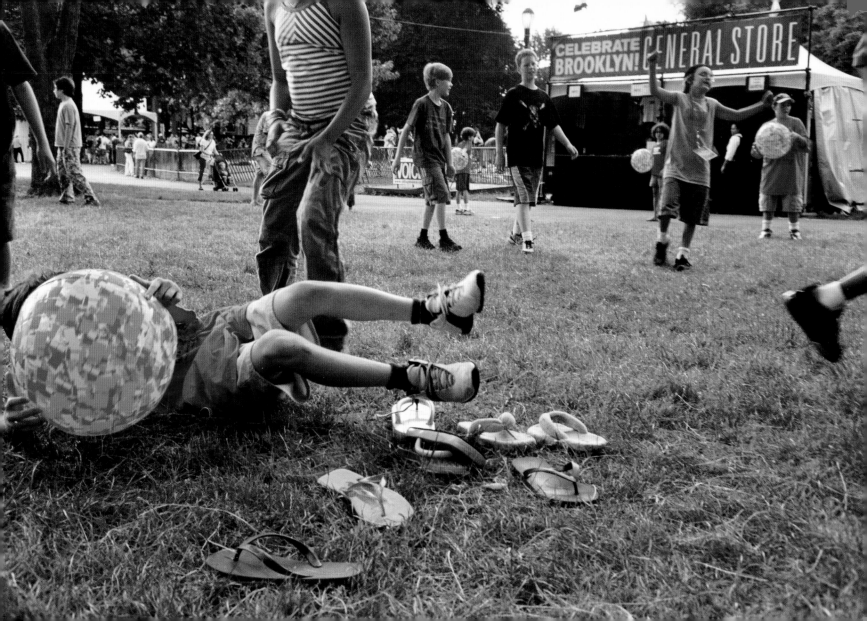

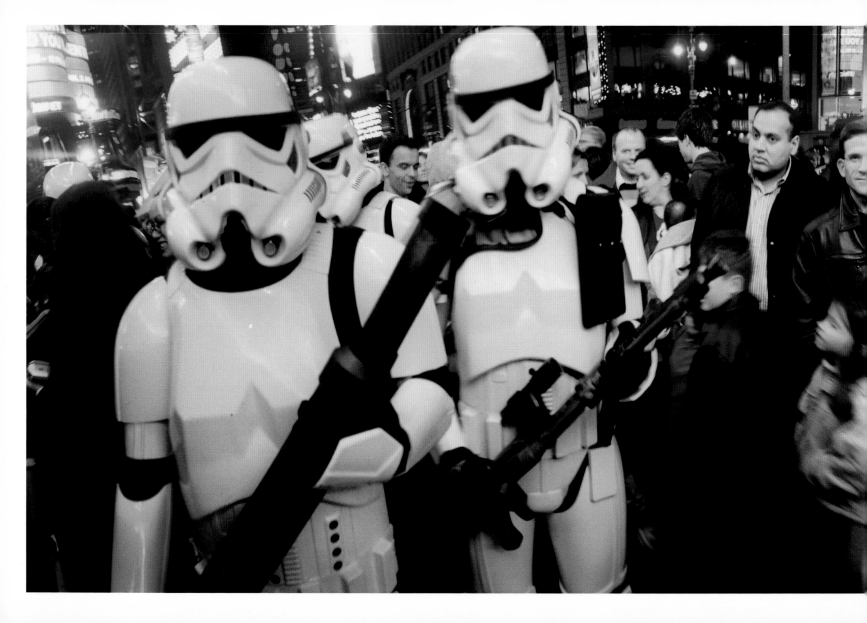

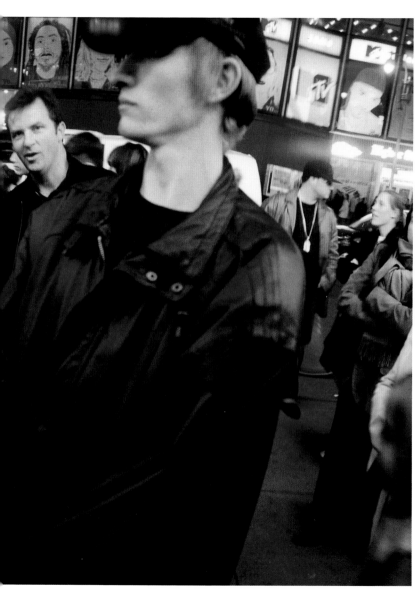

Star Wars fans line up outside
Toys R Us in Times Square

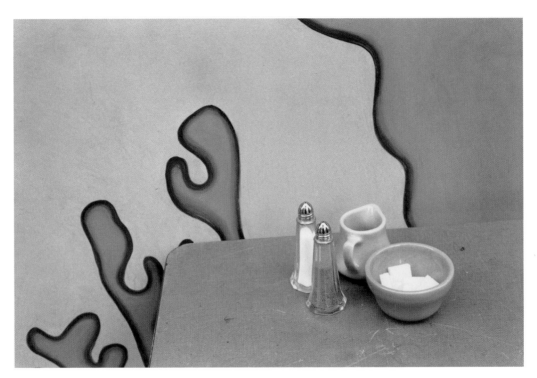

Above: A table at the filming of Julie Taymor's *Across the Universe*

Opposite: Bambi the Mermaid, Coney Island, Brooklyn

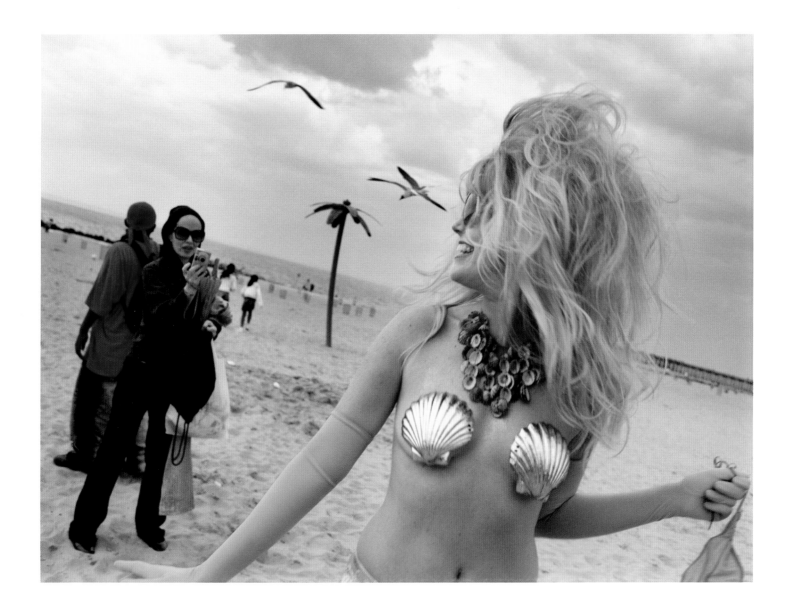

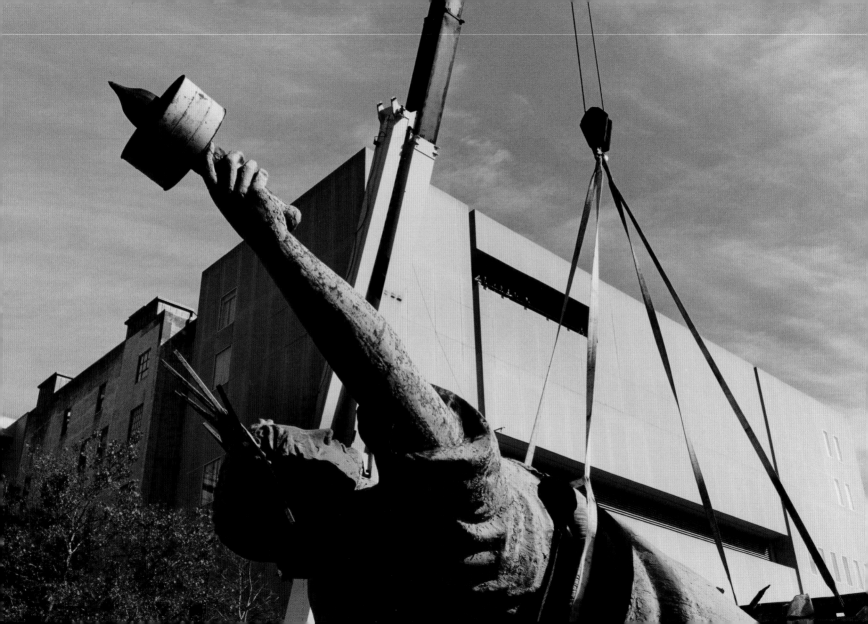

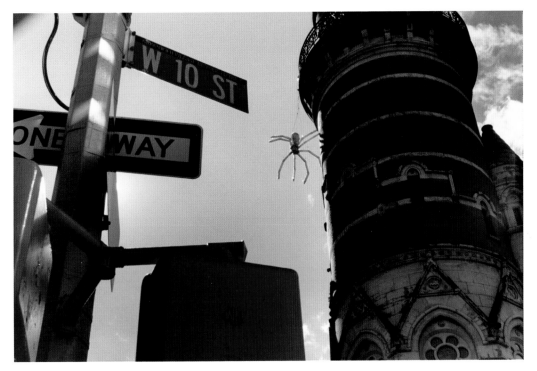

Opposite: Replica of the Statue of Liberty at the Brooklyn Museum

Above: Basil Twist's spider dangling from the tower
of the Jefferson Market branch of the New York Public Library

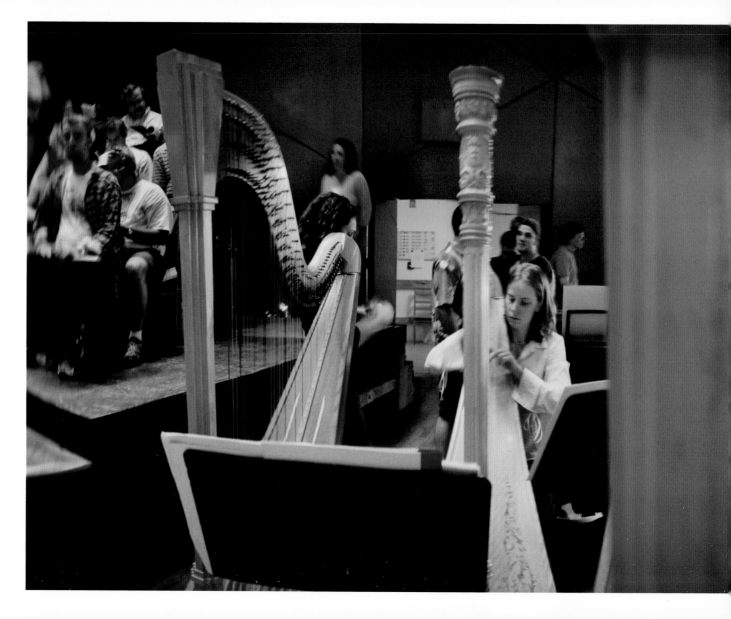

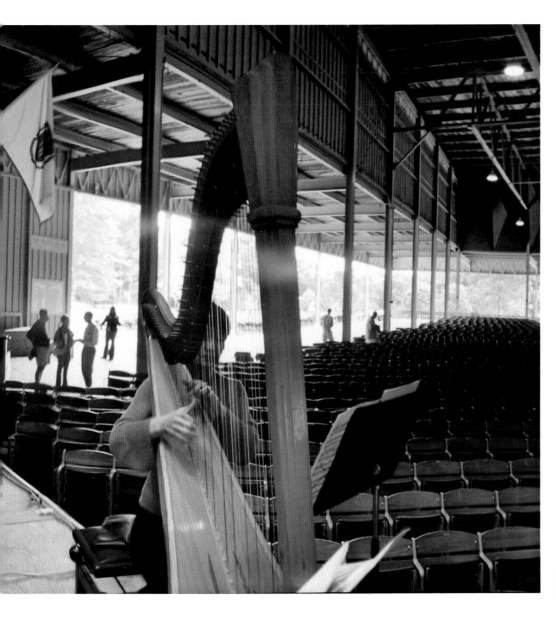

Harpists at the Tanglewood Shed,
Lenox, Massachusetts

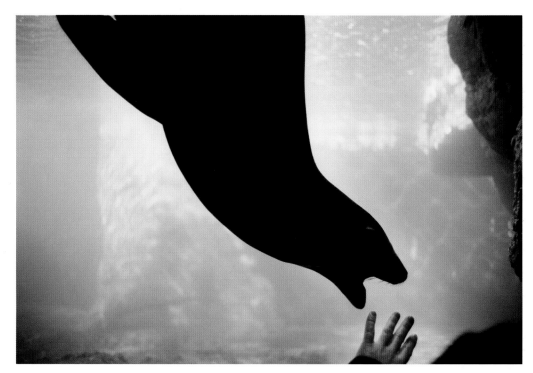

Above: A fur seal at the New York Aquarium, Coney Island, Brooklyn

Opposite: Aquila Theatre Company's *The Invisible Man*

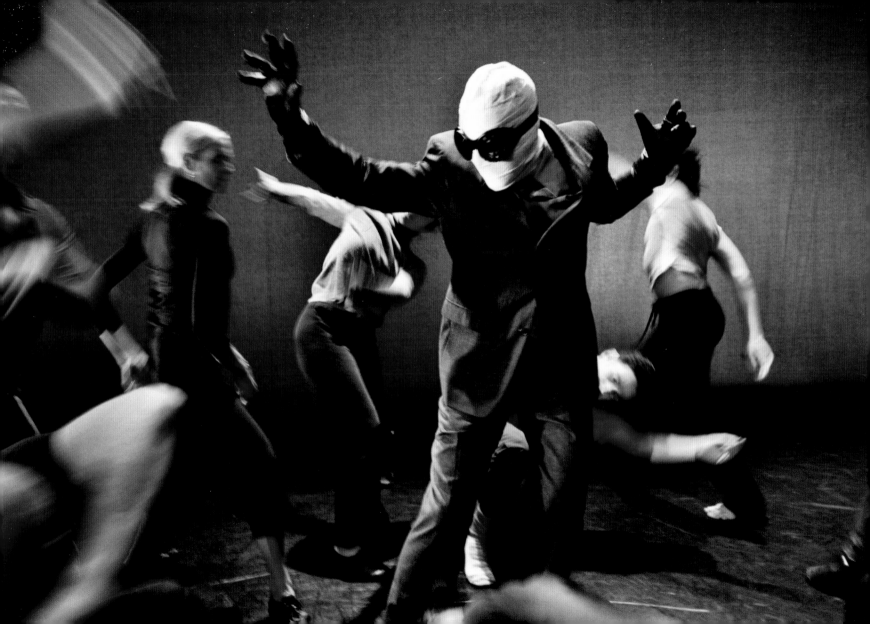

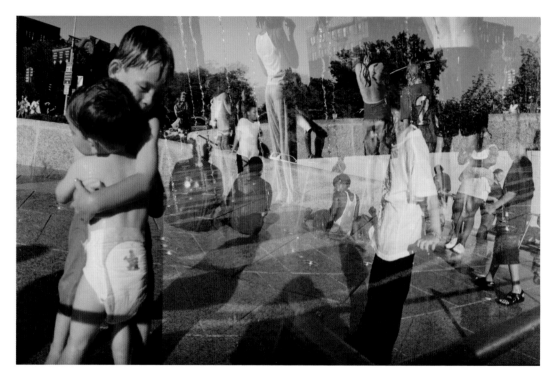

Above: Children playing in the fountains outside the Brooklyn Museum

Opposite: Adam Cvijanovic's work at the Bellwether Gallery

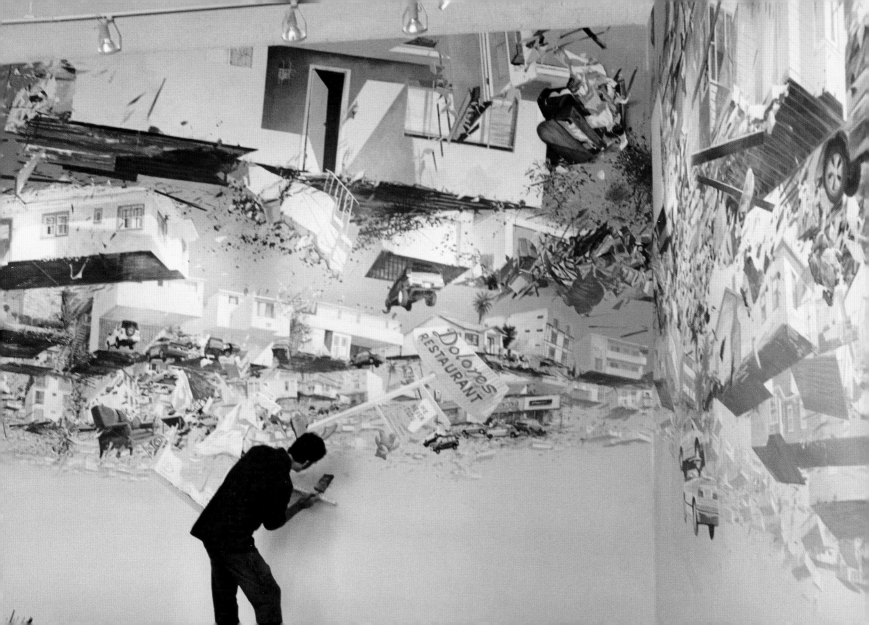

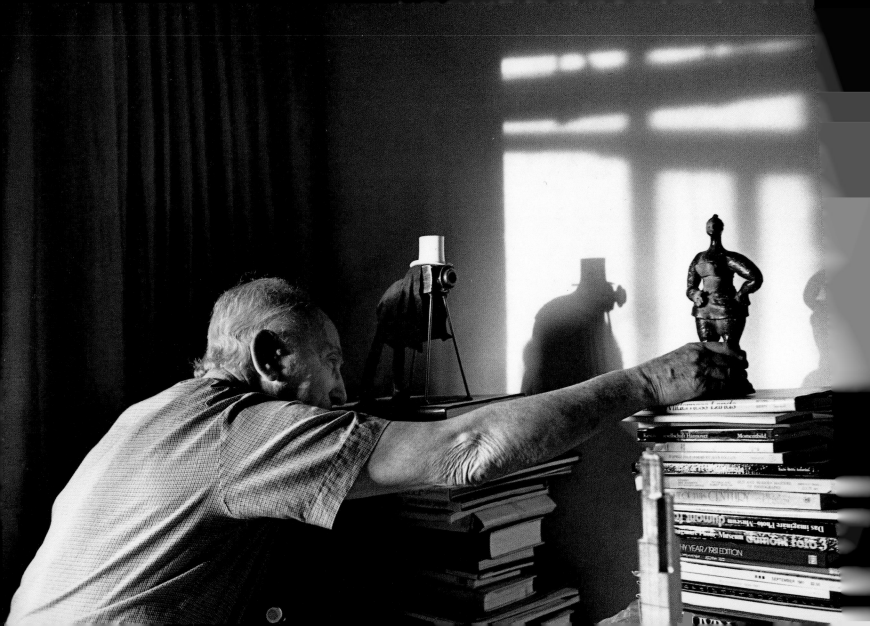

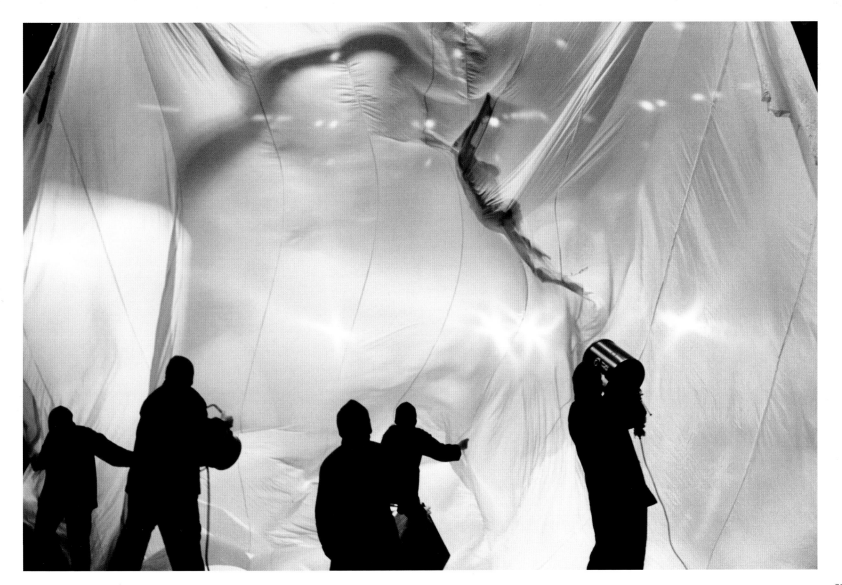

Opposite: André Kertész. Above: Mabou Mines' production of *Red Beads*, directed by Lee Breuer

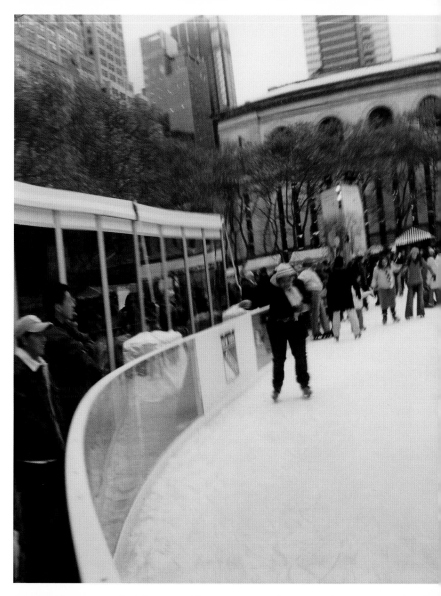

The Bryant Park ice rink

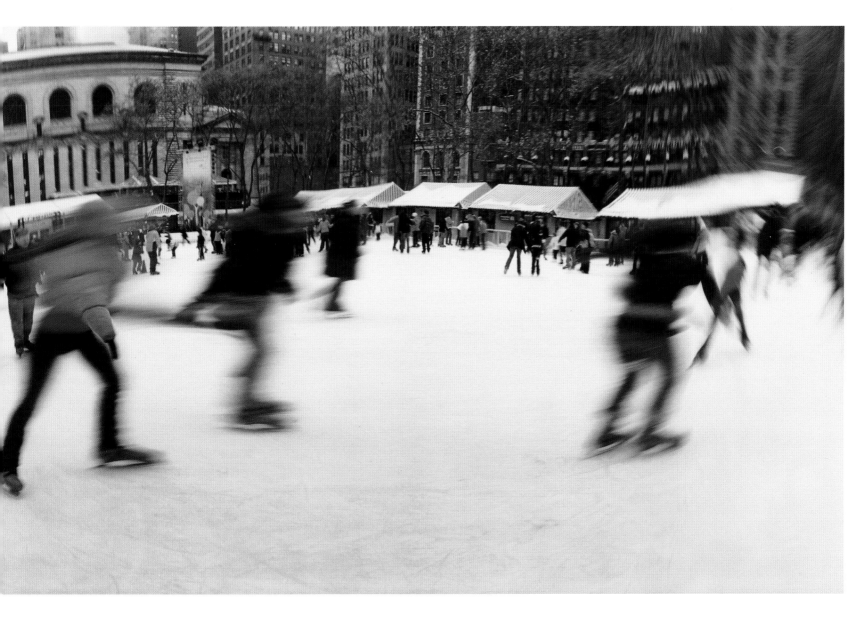

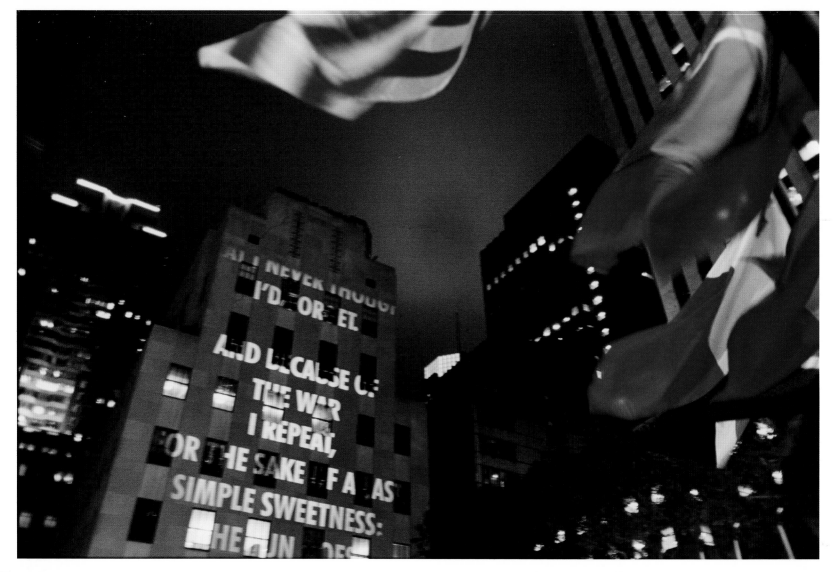

Jenny Holzer's *For the City*, light projections of poems on buildings

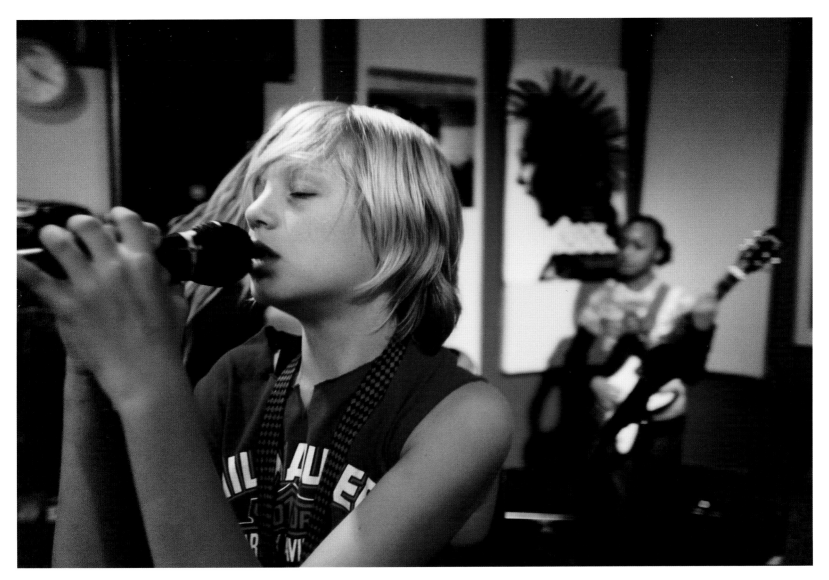

Students at the Paul Green School of Rock Music

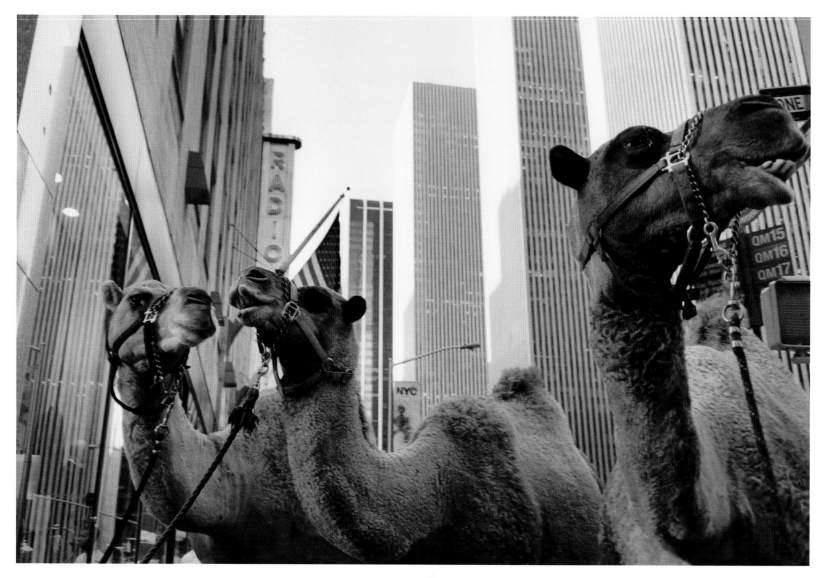

Above: Stars of the *Radio City Christmas Spectacular*. Opposite: Renovation of the Morgan Library & Museum

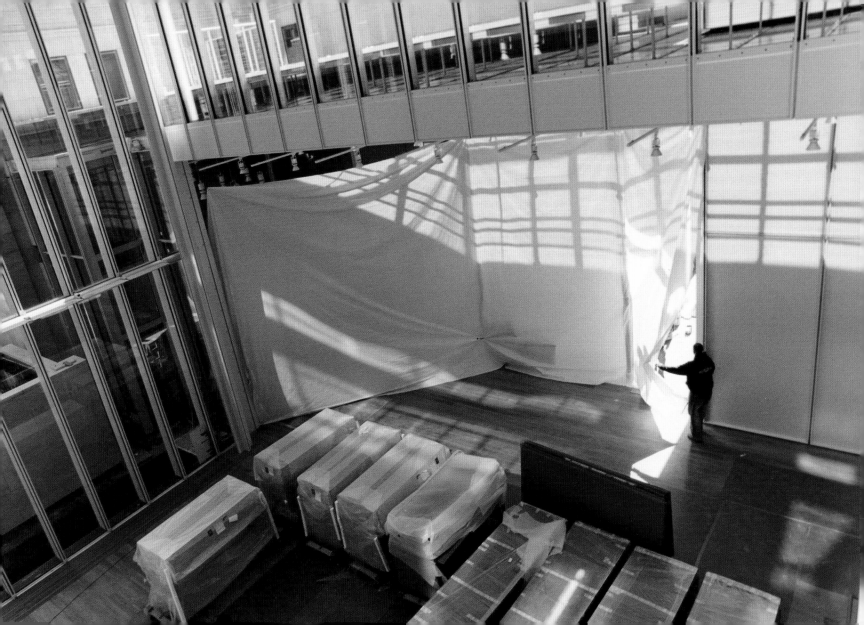

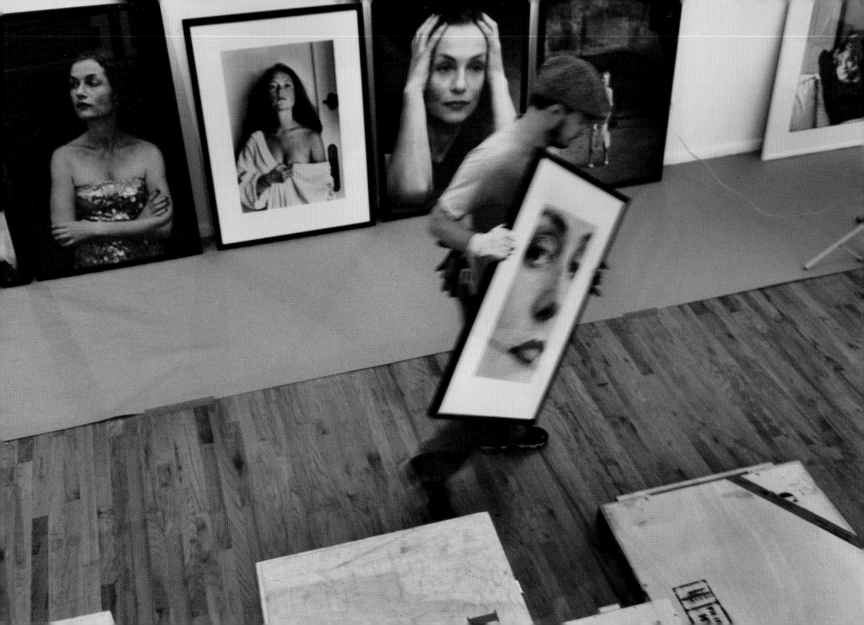

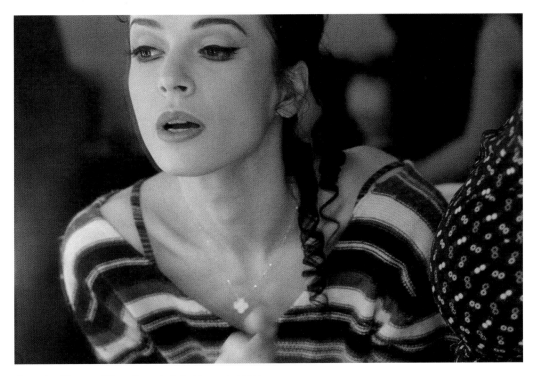

Opposite: *Woman of Many Faces: Isabelle Huppert* at P.S.1

Above: Diana Vishneva, of the American Ballet Theatre and the Kirov Ballet, preparing for the role of Giselle

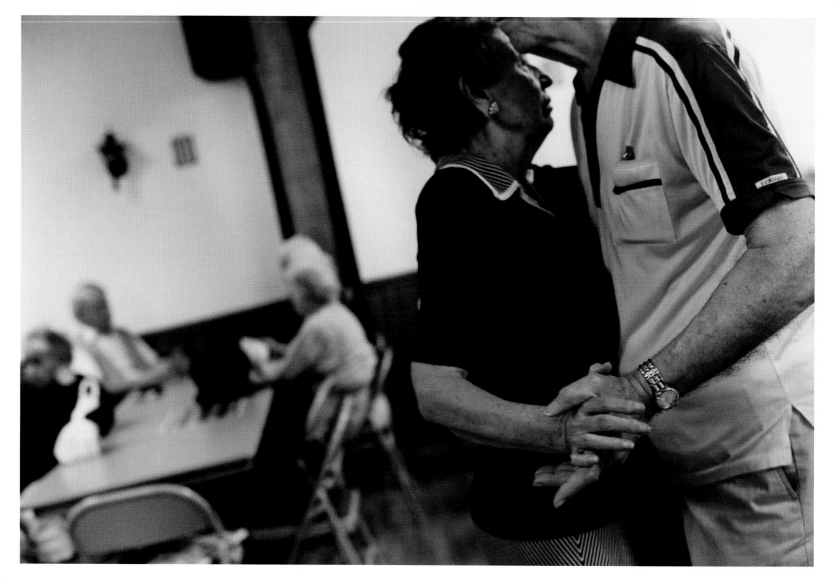

Social dance at the Forest Park Senior Citizens Center, Woodhaven, Queens

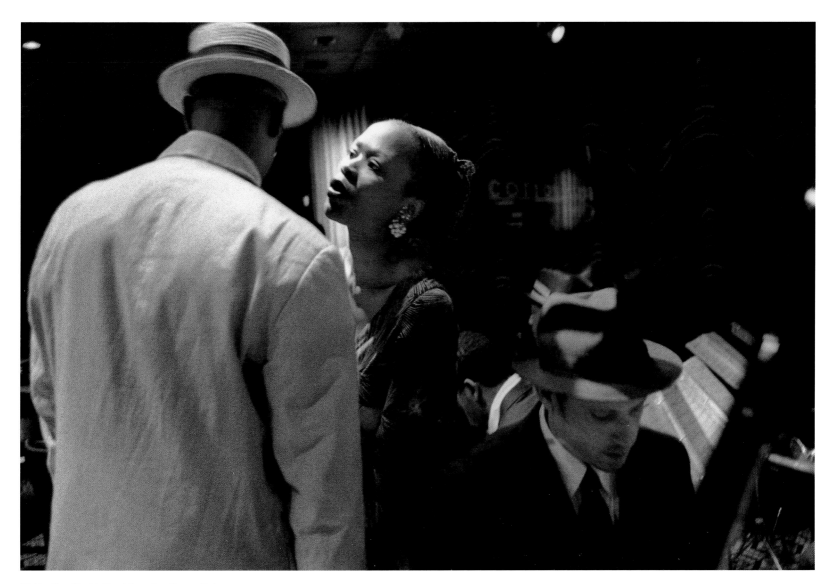

JC Hopkins Biggish Band featuring Queen Esther

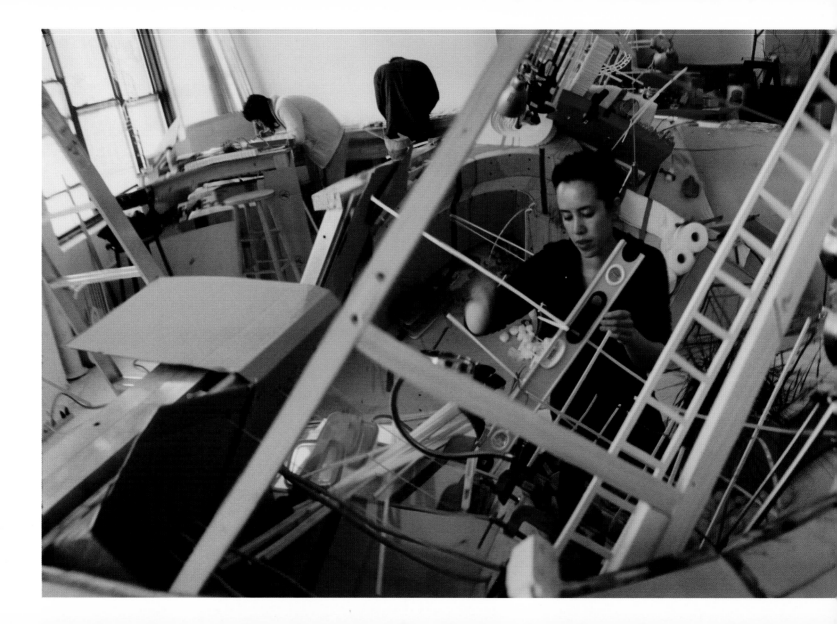

Sarah Sze, working on a new installation

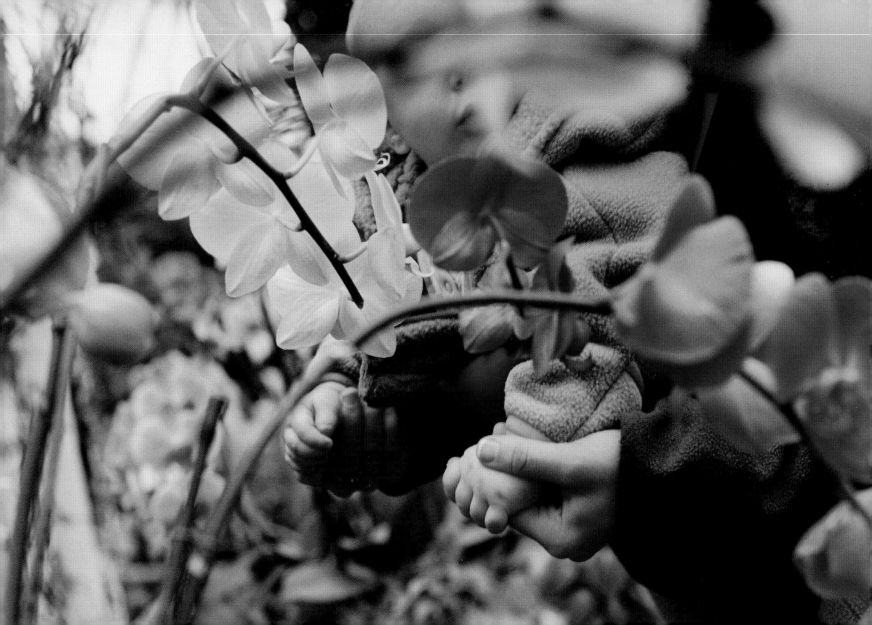

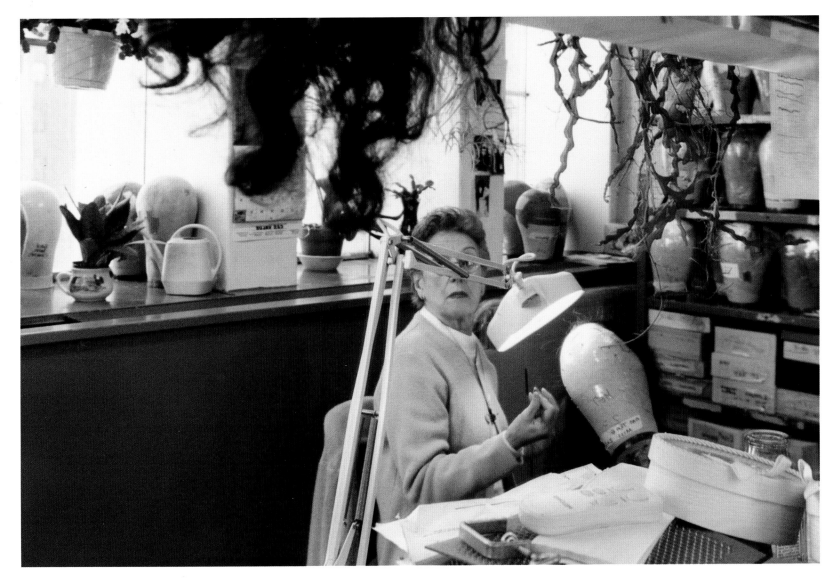

Opposite: Orchids at the New York Botanical Garden, Bronx. Above: A wigmaker at the Metropolitan Opera

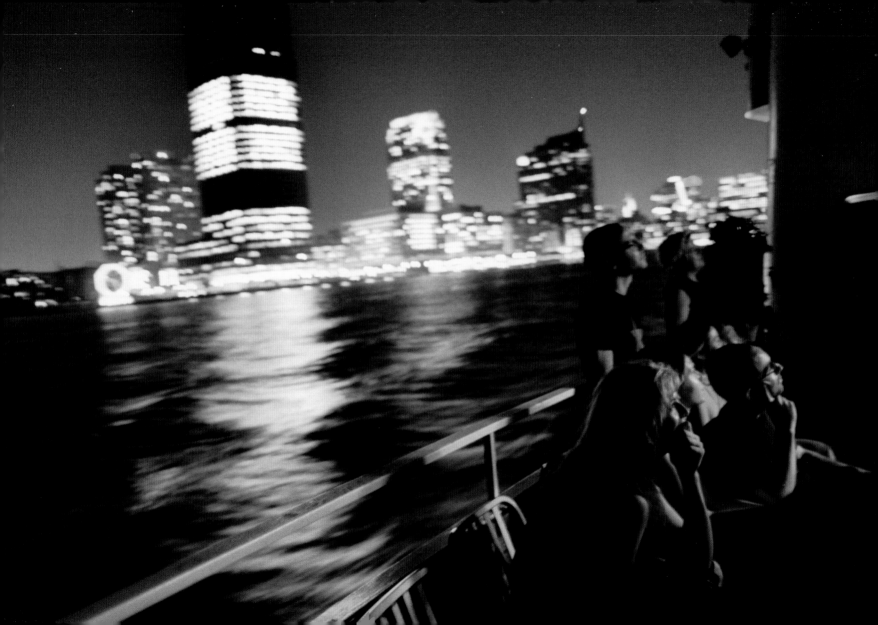

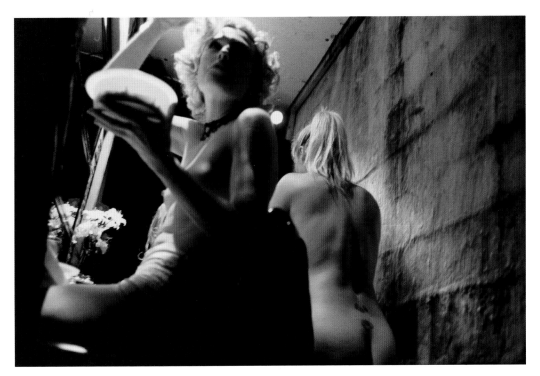

Opposite: A floating screening, part of the Rooftop Films series

Above: Burlesque at Galapagos, Williamsburg, Brooklyn

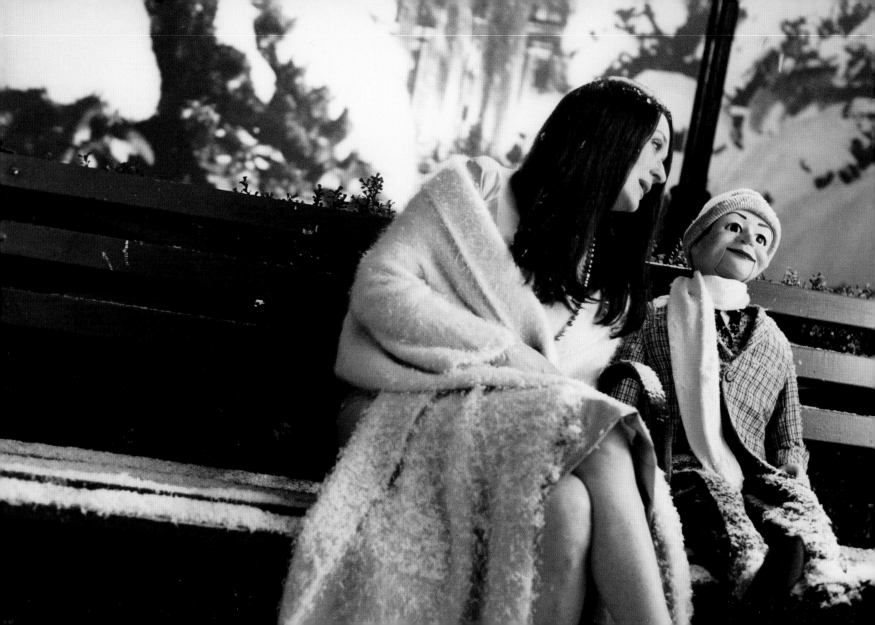

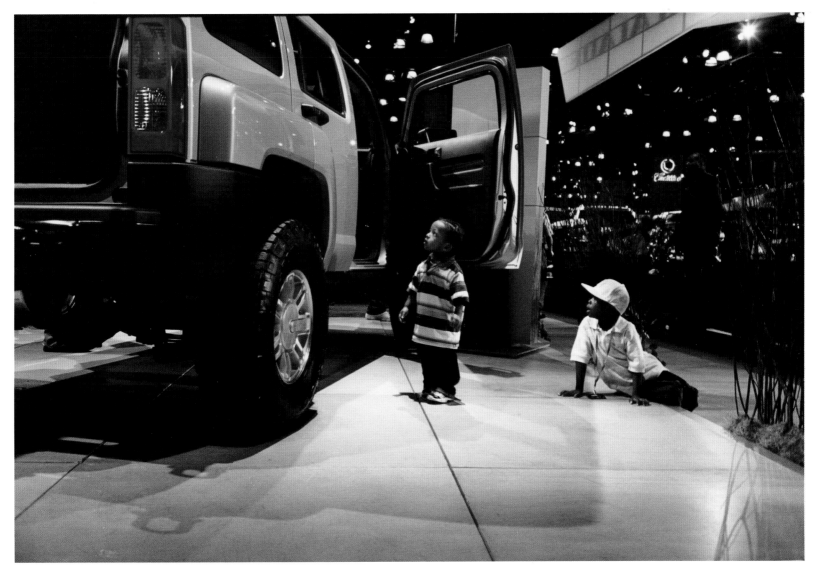

Opposite: Meryl Streep and a dummy in Laurie Simmons's film *The Music of Regret*. Above: The New York International Auto Show, at the Javits Center

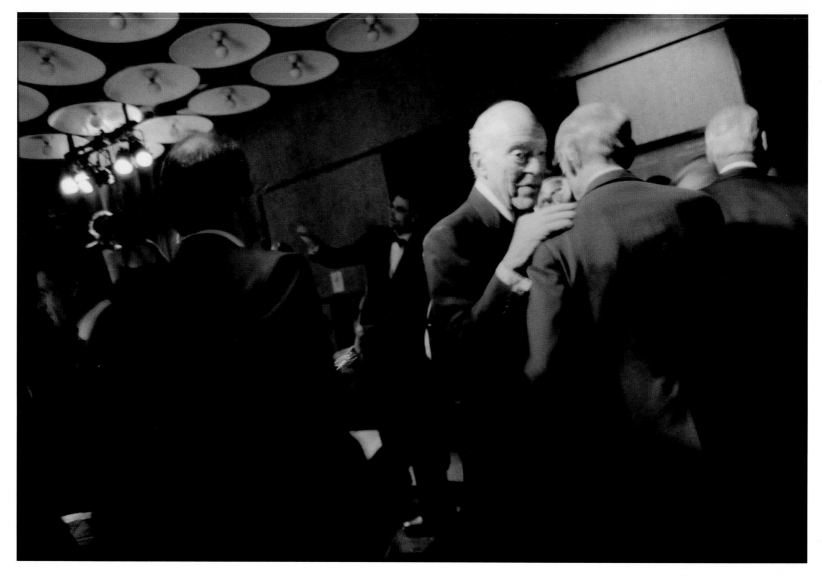

Leonard A. Lauder at the Whitney Museum of American Art gala

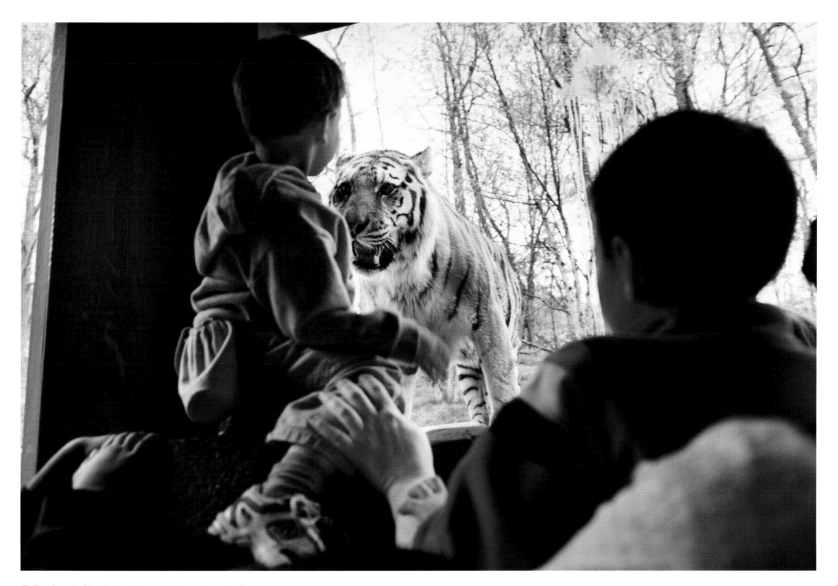

Zeff, a female Siberian tiger, at home at the Bronx Zoo

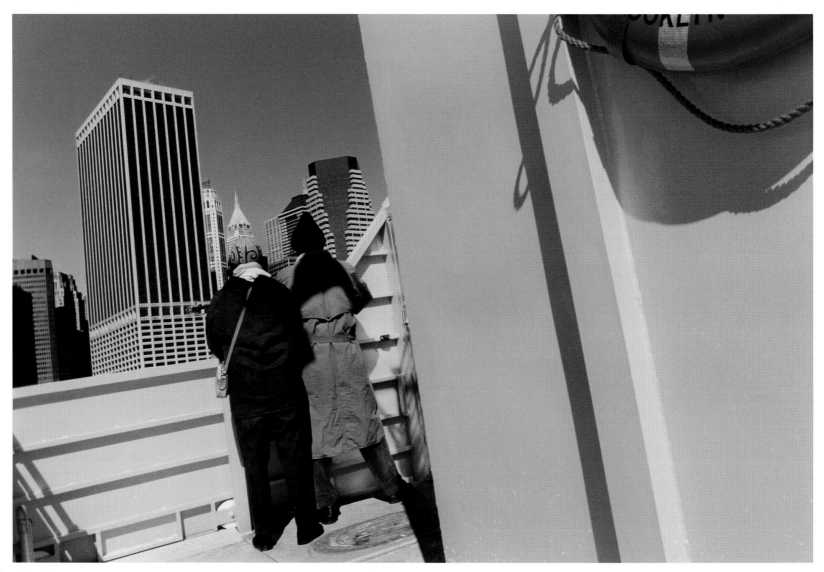

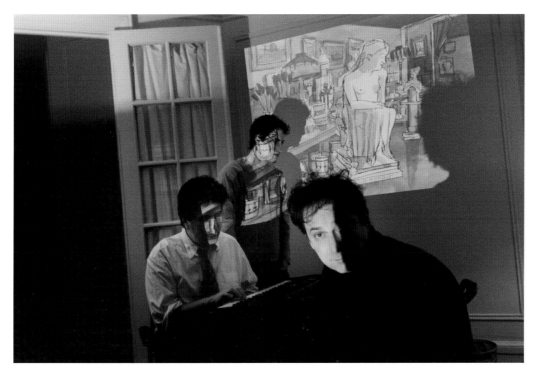

Opposite: A winter Eco-Adventure around New York Harbor, organized by New York City Audubon

Above: Ben Katchor and Mark Mulcahy's multimedia work *The Rosenbach Company*

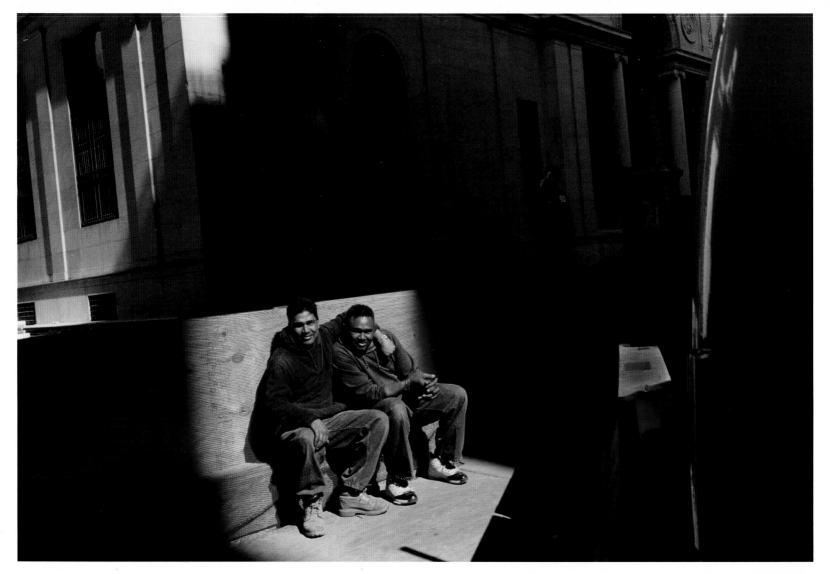

Above: Workers on break outside the Morgan Library & Museum. Opposite: On the set of the movie version of Mel Brooks's *The Producers*

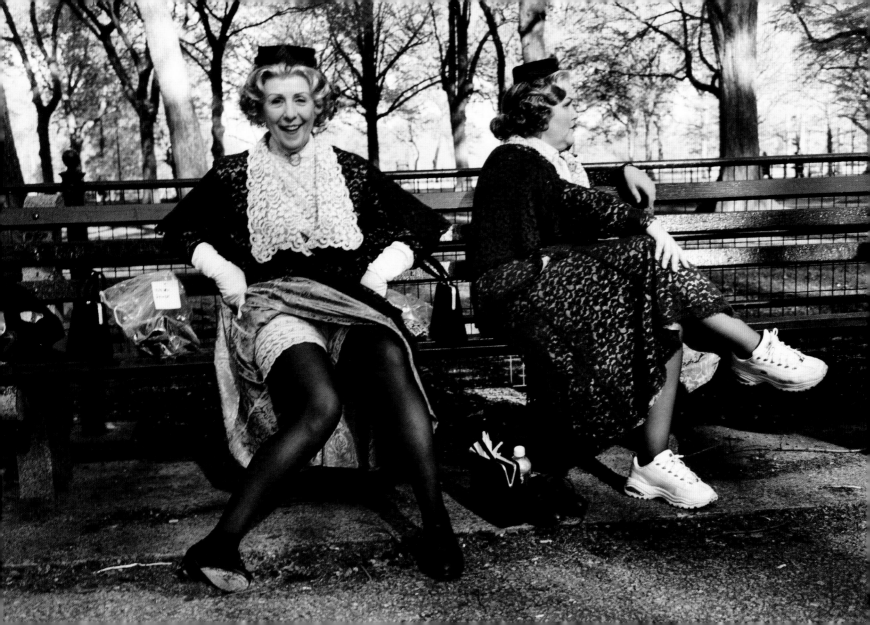

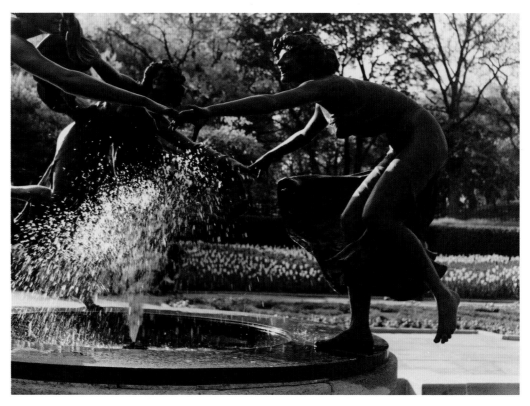

Above: The Conservatory Garden in Central Park

Opposite: Glimmerglass Opera, Cooperstown, New York

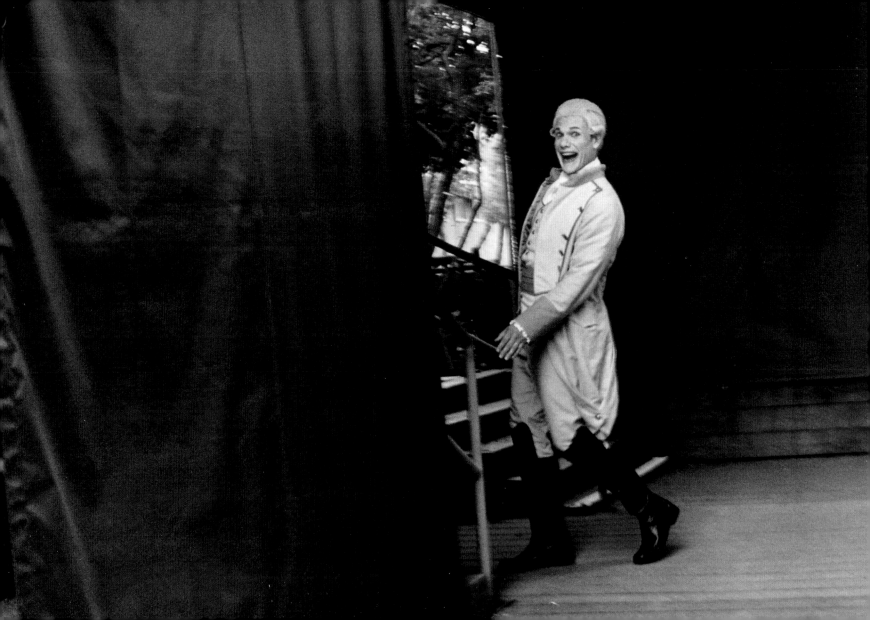

The Orchid Show at
the New York Botanical
Garden, Bronx

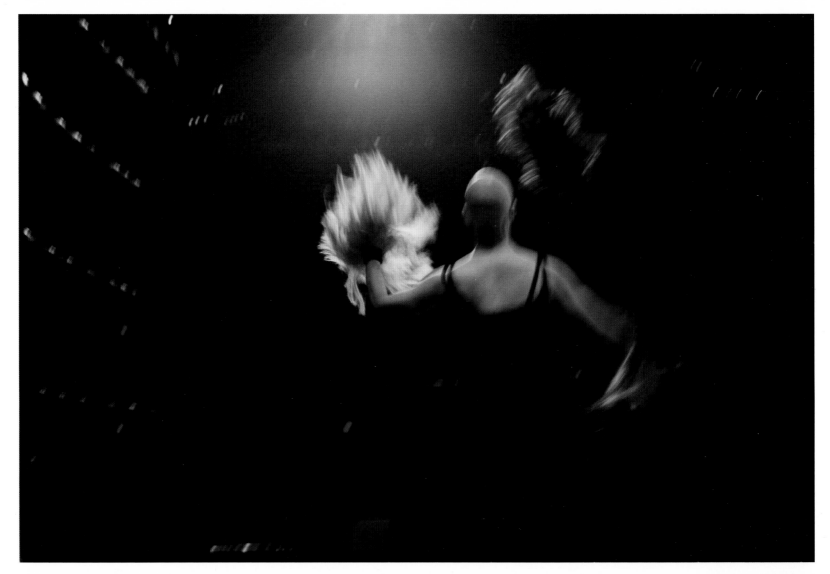

A juggler at Cirque Éloize

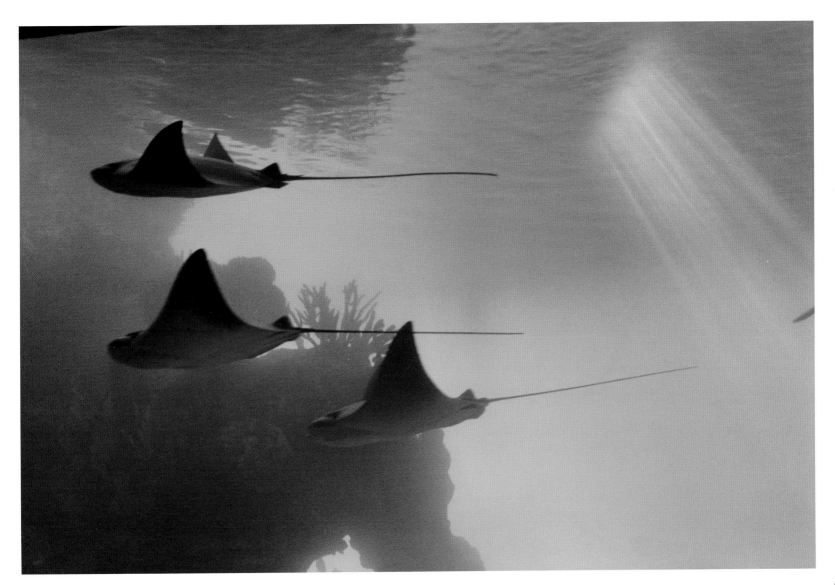

Manta rays at the New York Aquarium, Coney Island, Brooklyn

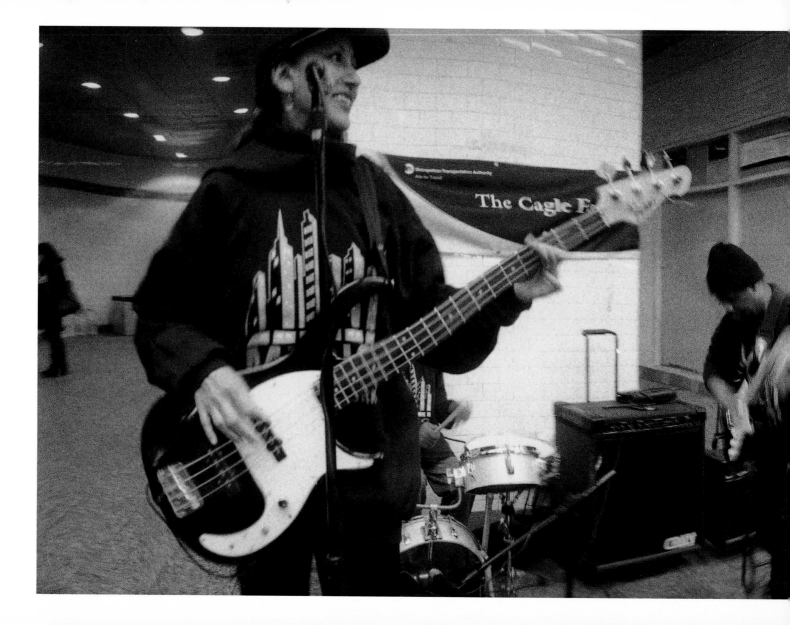

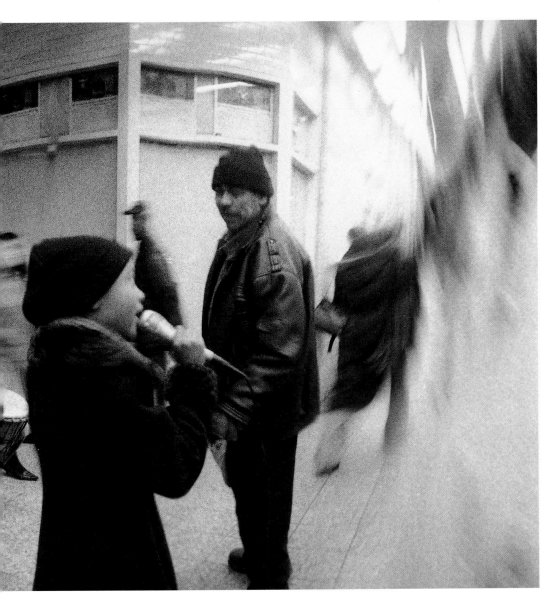

The Cagle family, in the
New York City subway

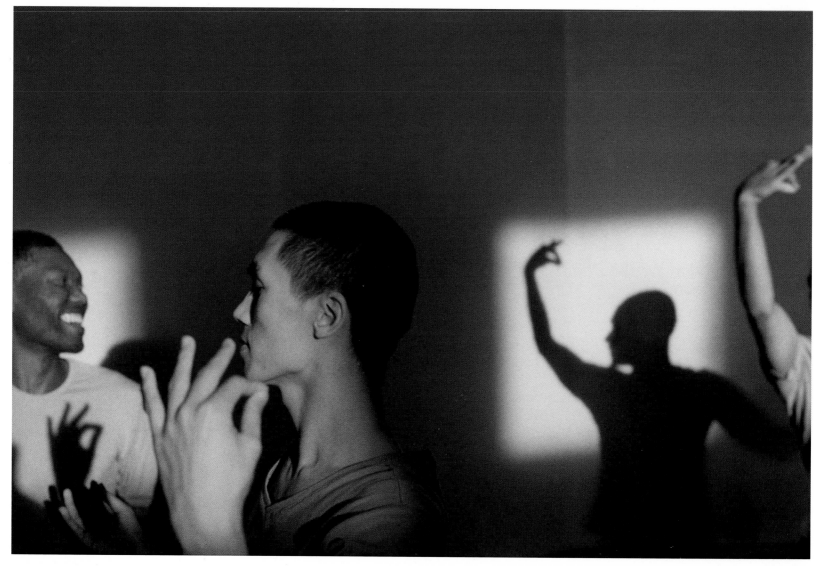

Above: *Variations for Vibes, Pianos and Strings,* Akram Khan's dance piece to the music of Steve Reich, at the Brooklyn Academy of Music. Opposite: Amadou et Mariam at Joe's Pub

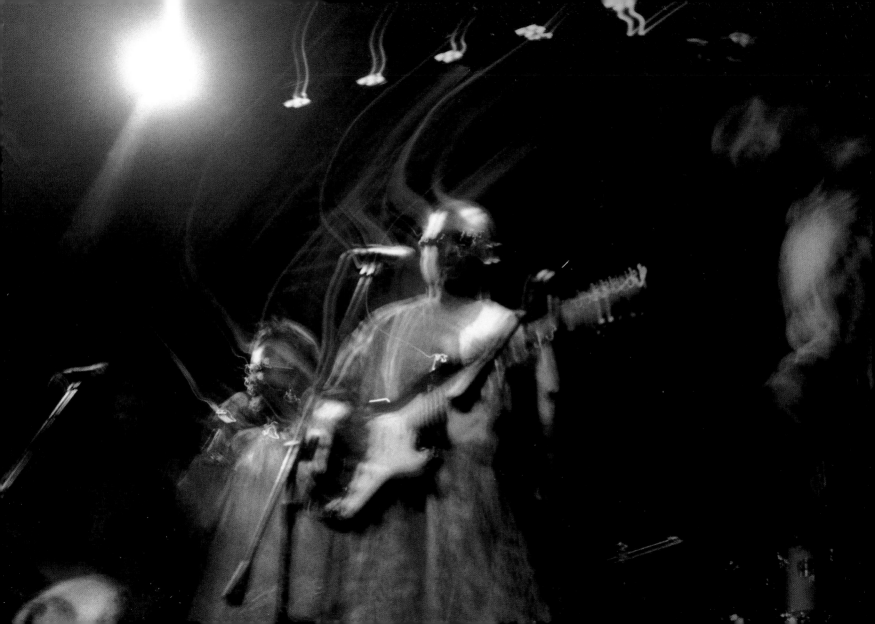

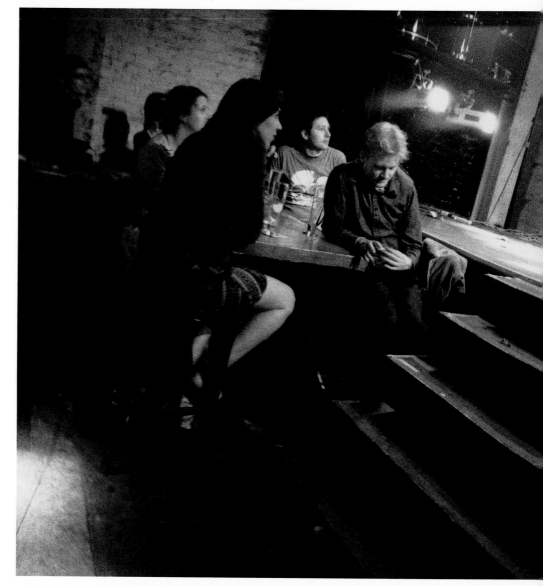

Julie Atlas Muz onstage
at Galapagos, Williamsburg, Brooklyn

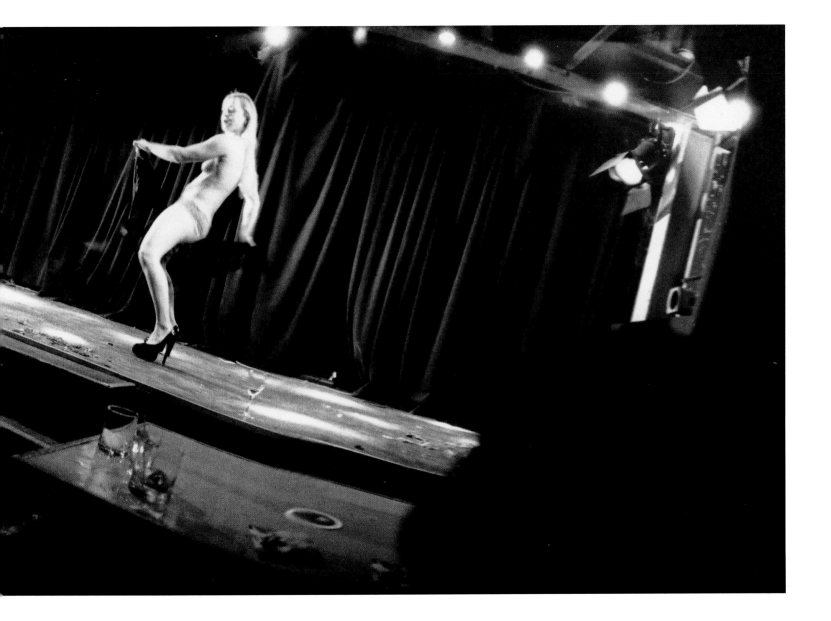

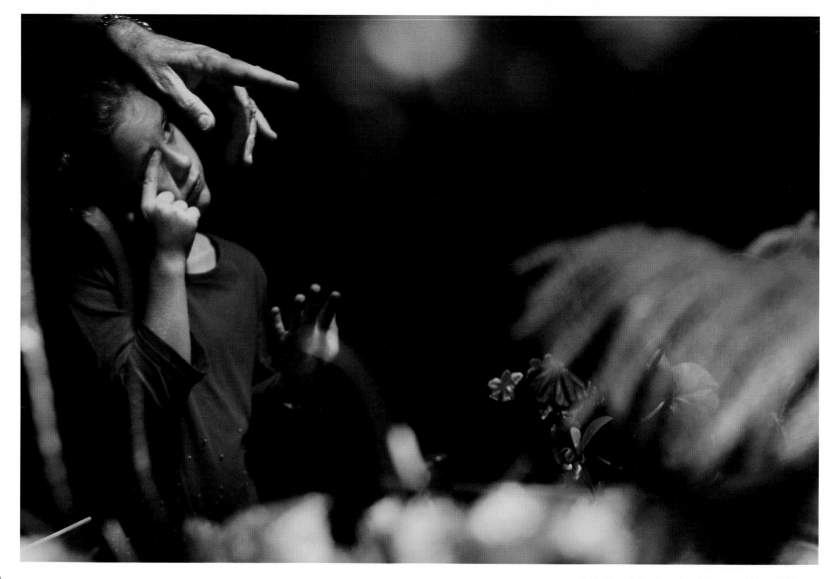

Butterflies at the American Museum of Natural History

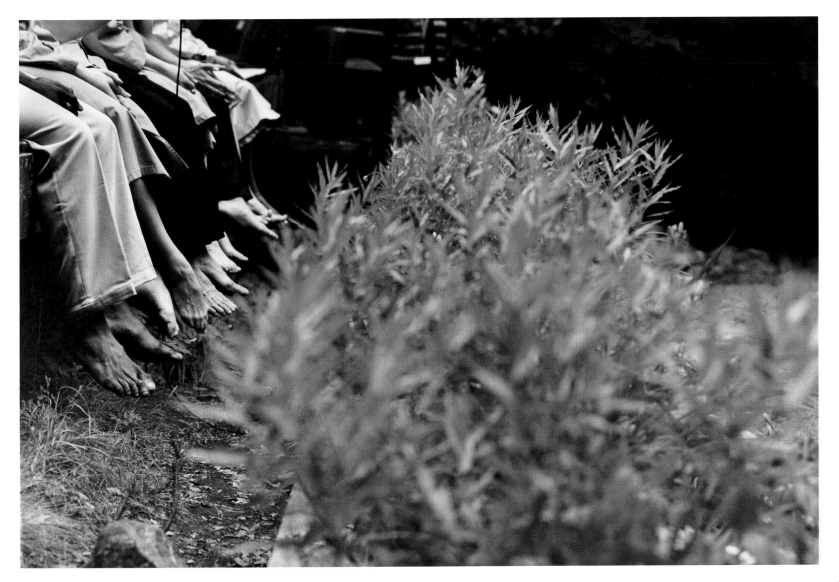

A post-performance talk by dancers at Jacob's Pillow, Becket, Massachusetts

"Wildman" Steve Brill foraging
in Forest Park, Queens

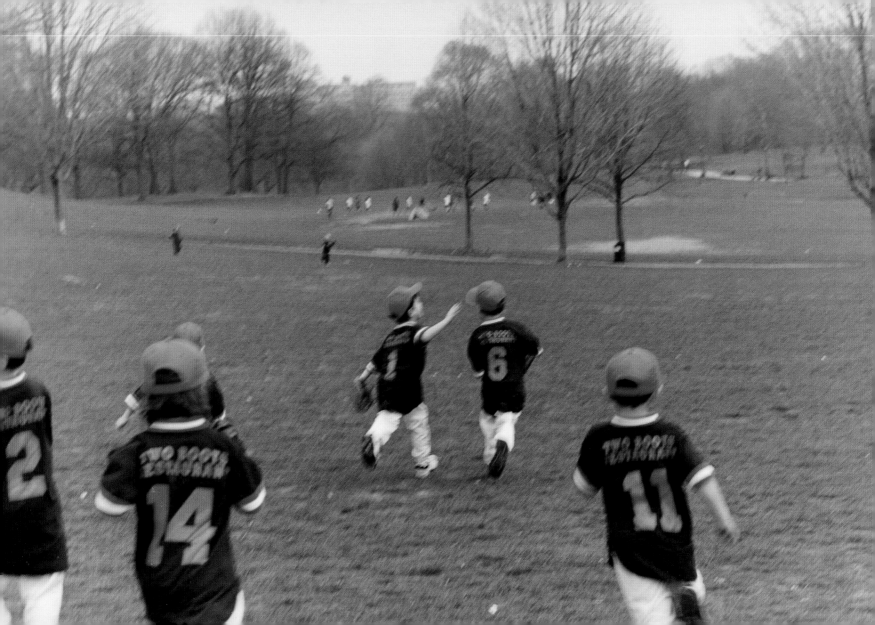

Opposite: The opening day of Little League in Prospect Park, Brooklyn. Above: Macy's warehouse, before the Thanksgiving Day Parade

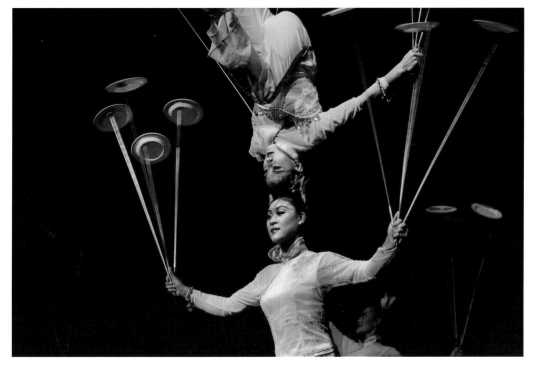

Opposite: Dizzy's Club Coca-Cola

Above: Golden Dragon Acrobats, at the New Victory Theater

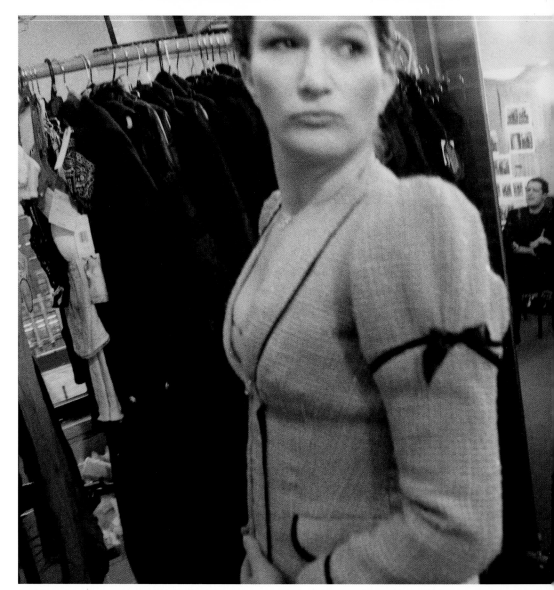

Ana Gasteyer, at a costume fitting
for the Roundabout Theatre's
production of *The Threepenny Opera*

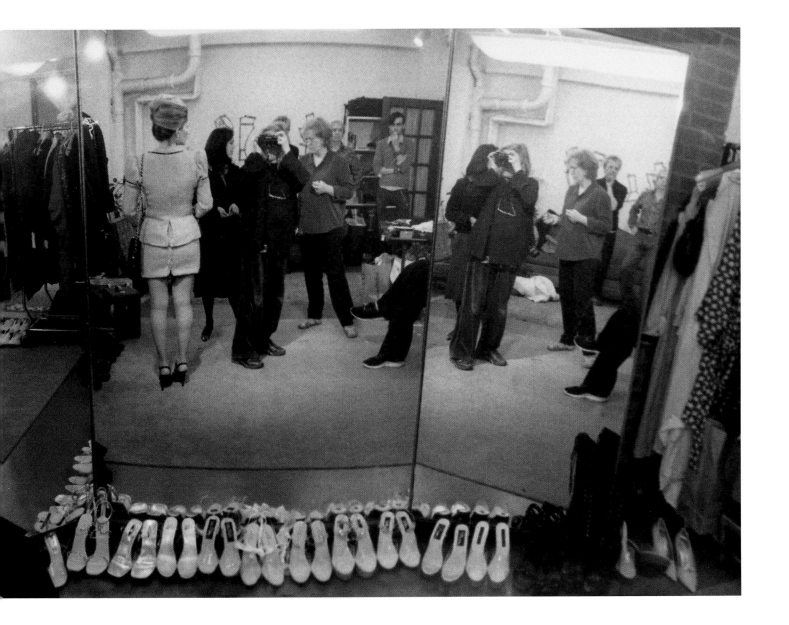

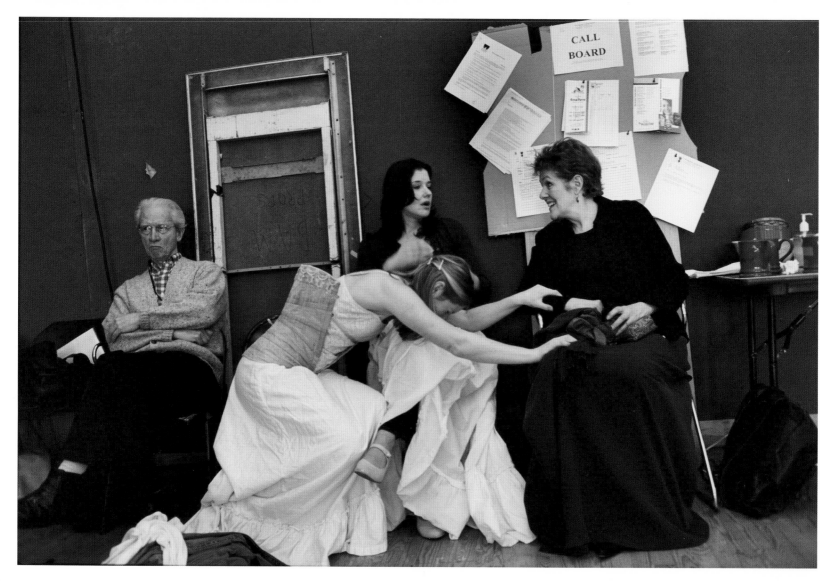

Lynn Redgrave, the star of *The Importance of Being Earnest*, at the Brooklyn Academy of Music

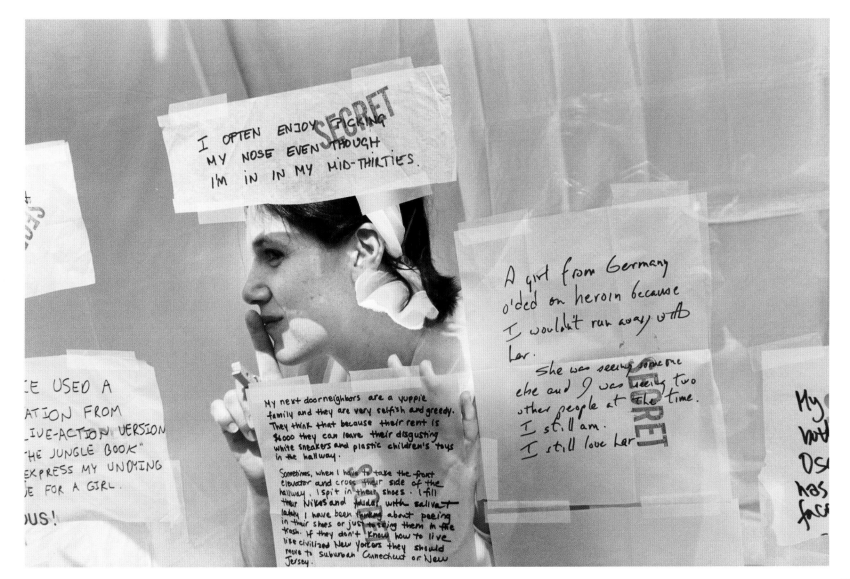

Inside/Out, a storefront public-art event in midtown

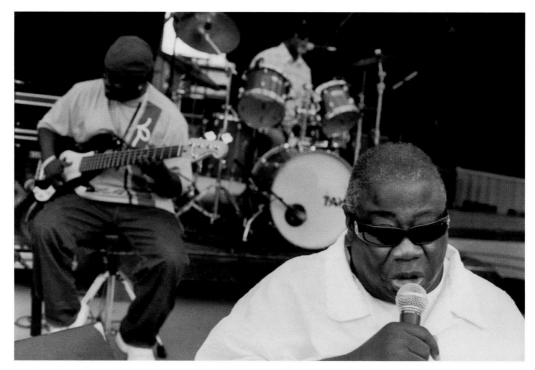

Above: The Blind Boys of Alabama, in Central Park

Opposite: The male chorus Chanticleer, at the Metropolitan Museum of Art

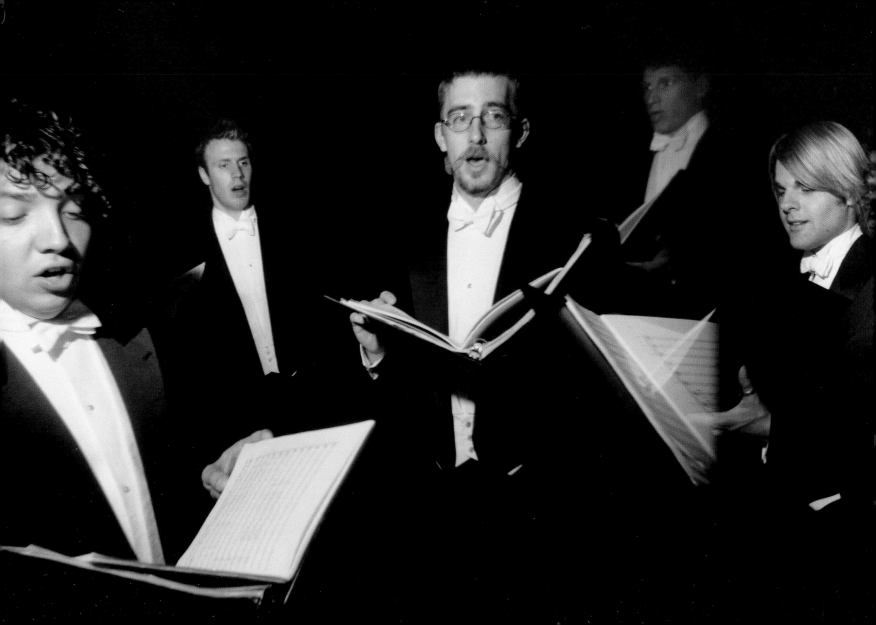

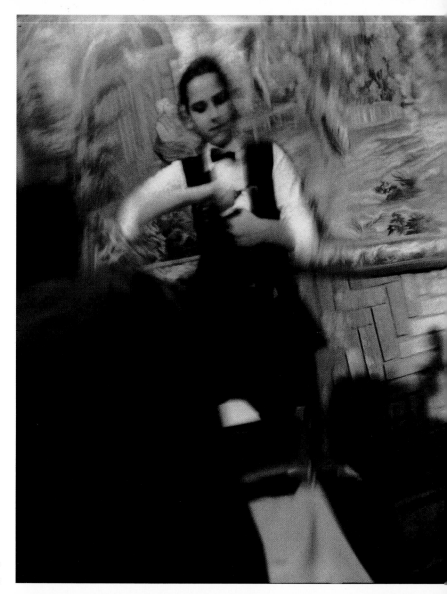

Matt Haimovitz with his cello
at Casa Romana restaurant, Queens

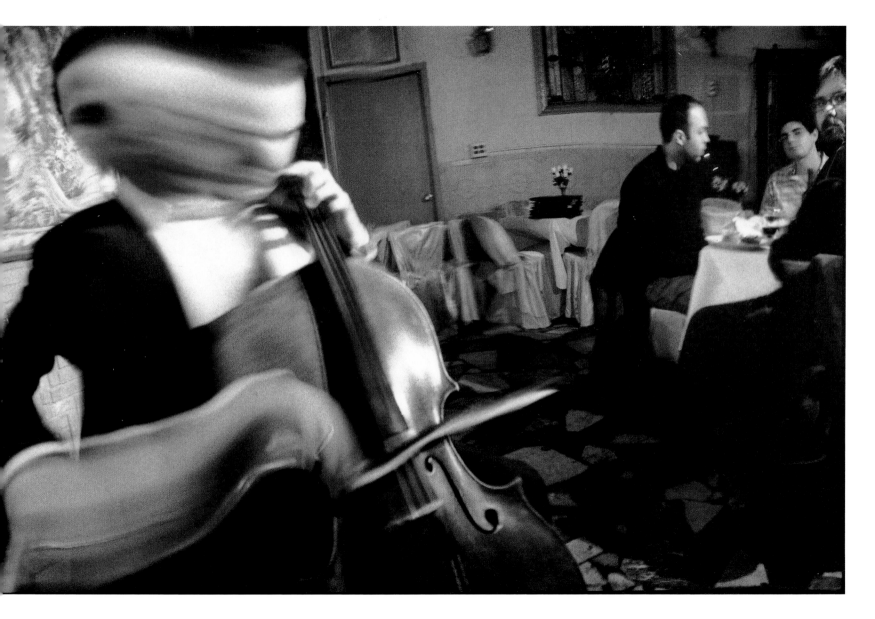

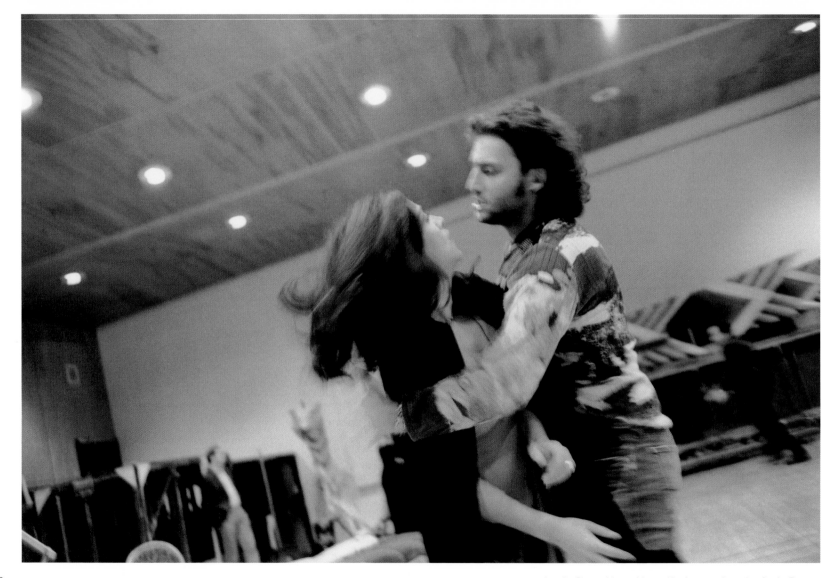

Angela Gheorghiu and Jonas Kaufmann rehearsing for *La Traviata*

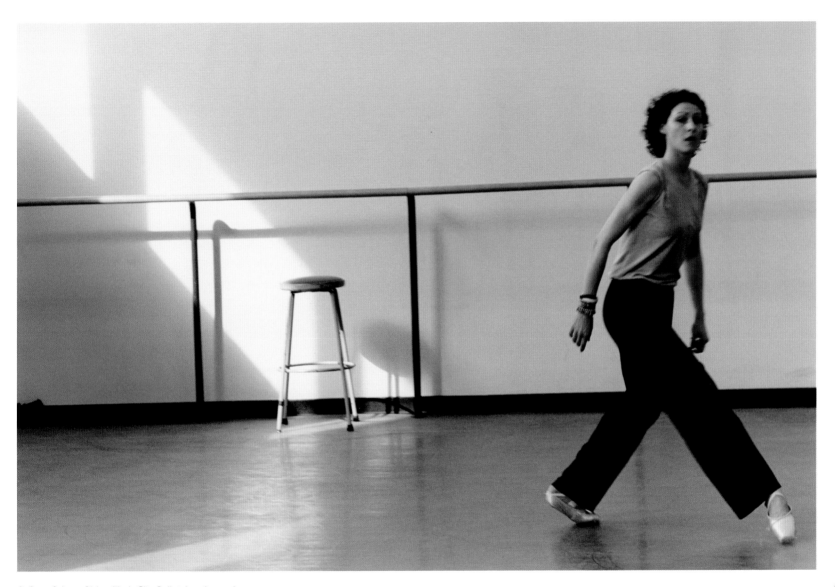

Sofiane Sylve, of New York City Ballet, in rehearsal

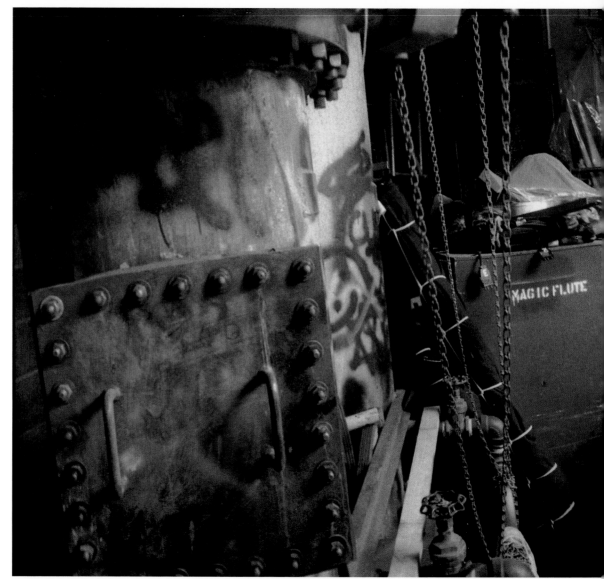

Backstage props at
the Metropolitan Opera

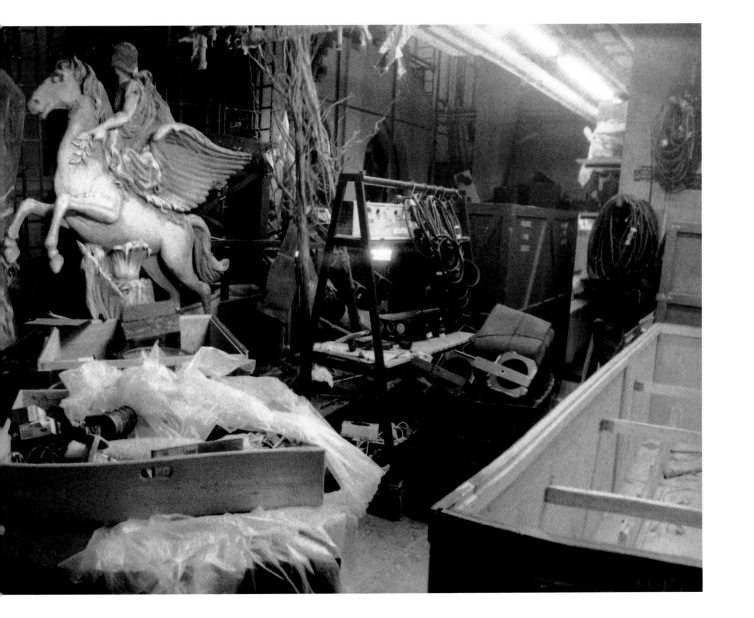

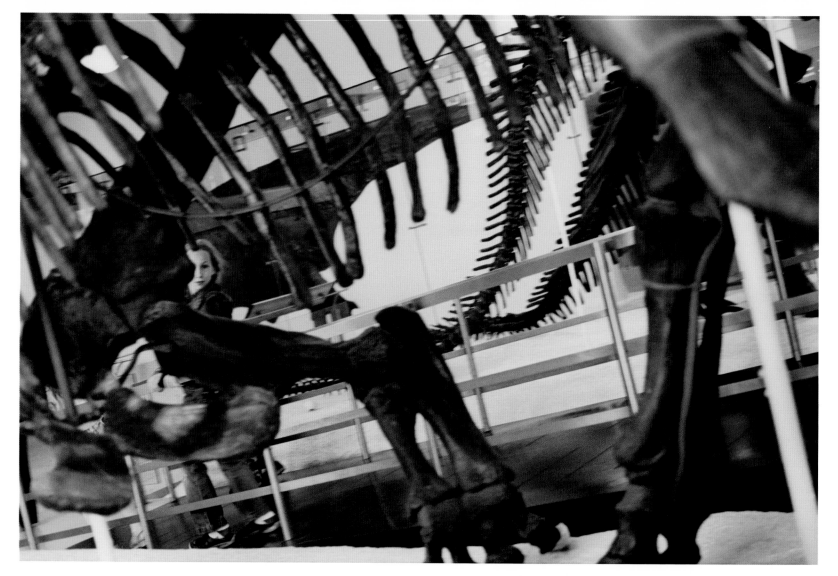

Hall of Ornithischian Dinosaurs at the American Museum of Natural History

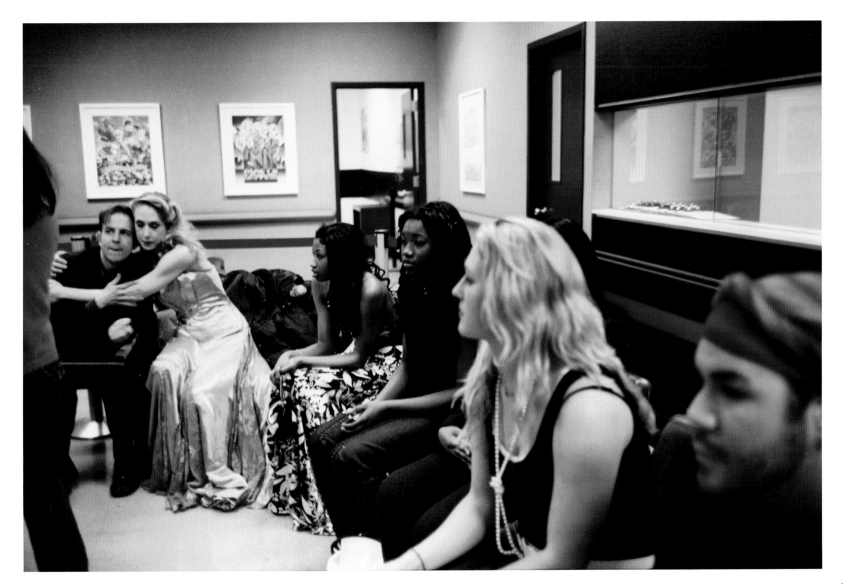

Aspiring fashion designers at an open call for *Project Runway*

Chanel, an exhibition about
the fashion designer, at the
Metropolitan Museum of Art

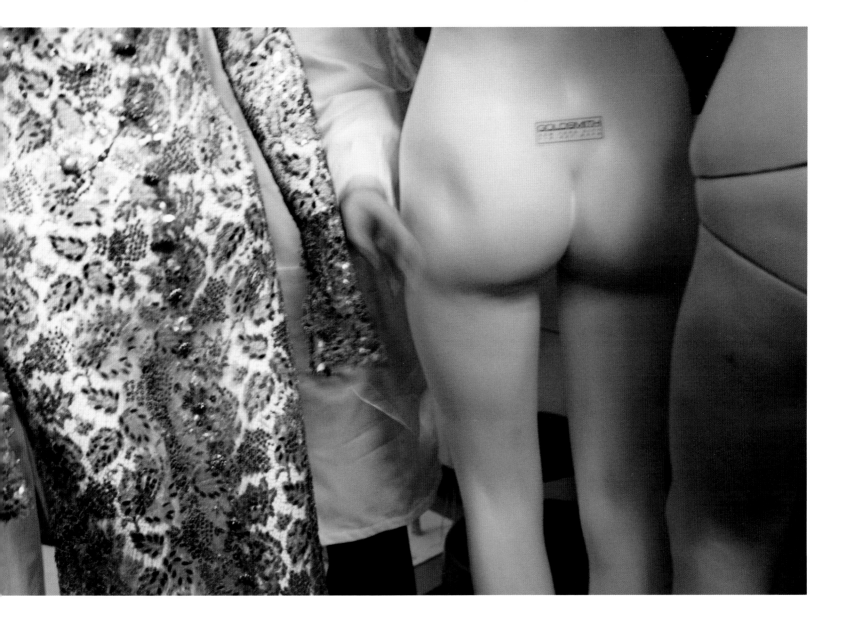

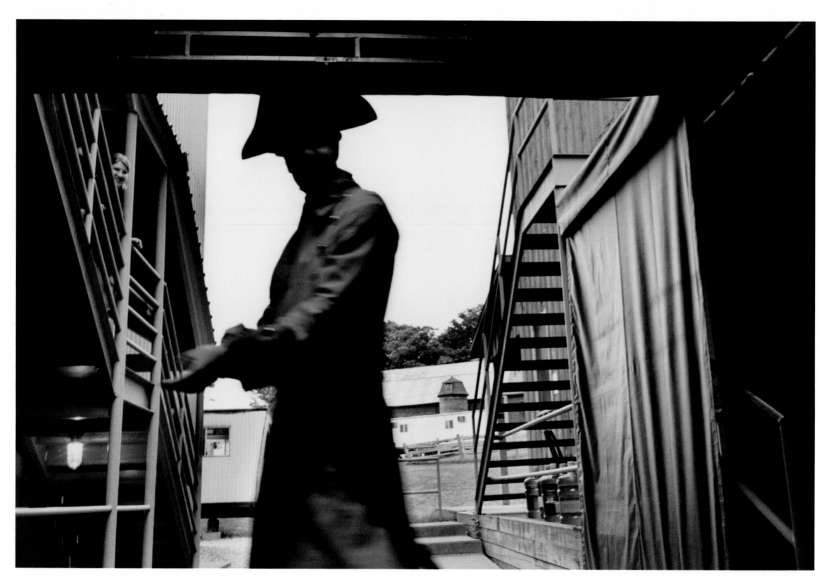

Così fan Tutte at Glimmerglass Opera, Cooperstown, New York

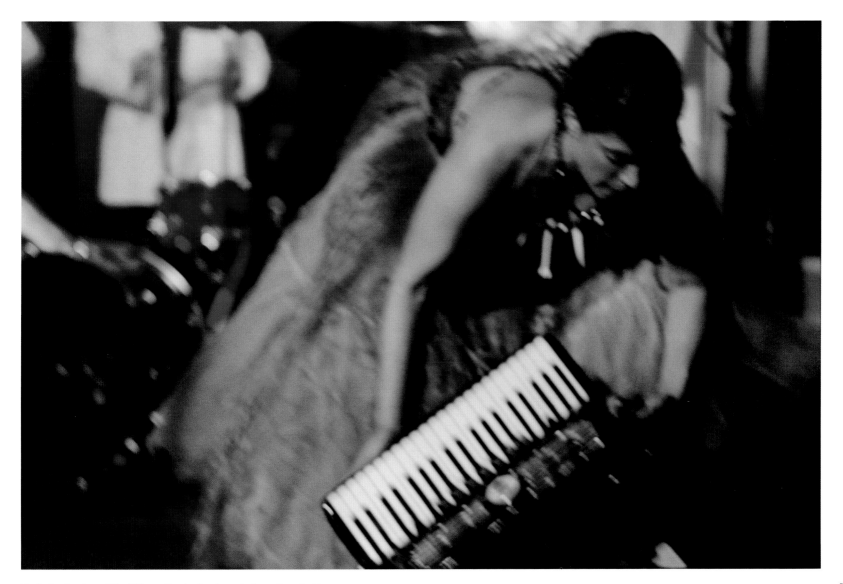

Rachelle Garniez, of the Citizens Band, a local acrobatic and musical troupe

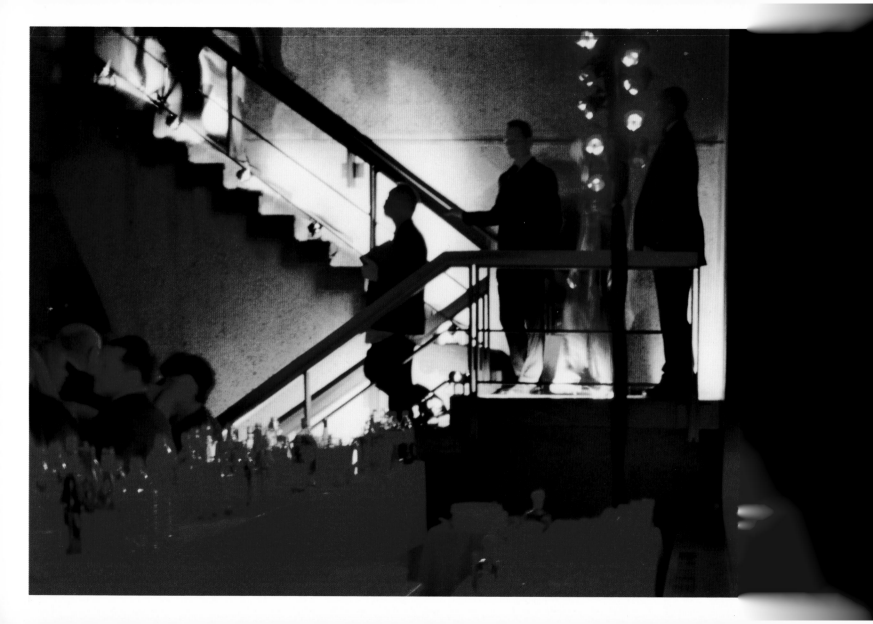

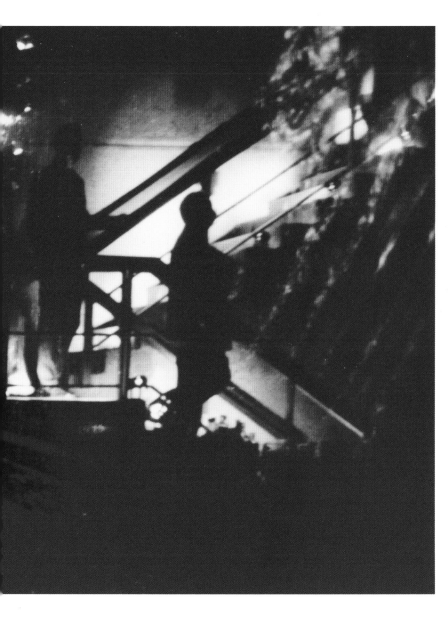

Staircase to the bar at
an opening at the Whitney
Museum of American Art

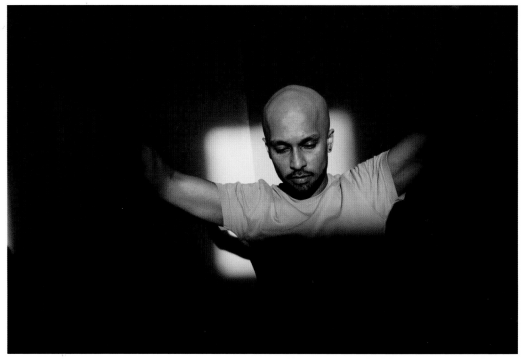

Above: Akram Khan at the Brooklyn Academy of Music

Opposite: Blondie's Deborah Harry, in a Richard Move dance production at the Kitchen

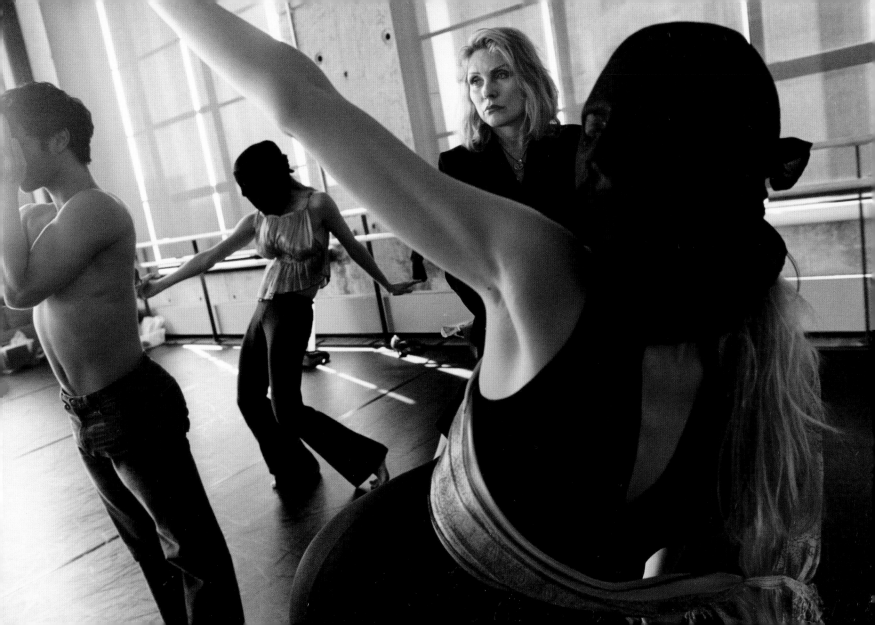

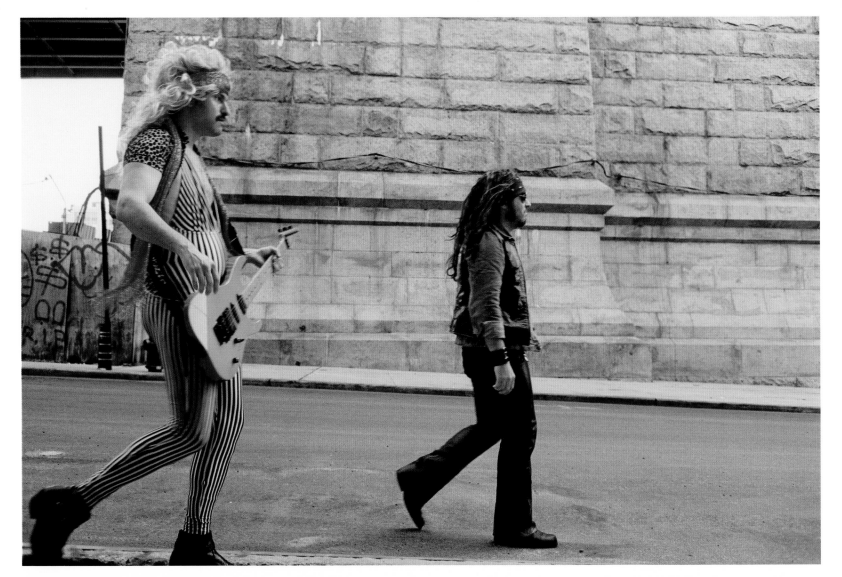

The New Jersey–based hard-rock band Satanicide

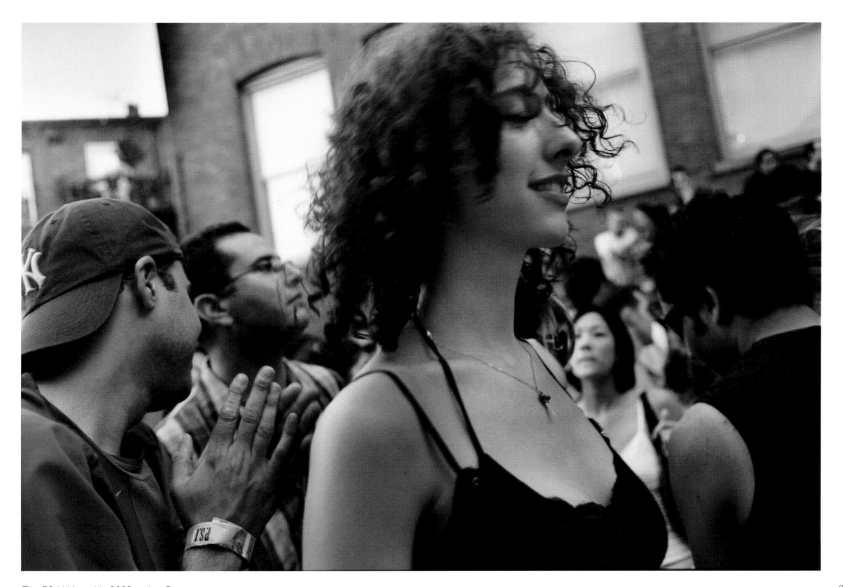

The P.S.1 Warm Up 2005 series, Queens

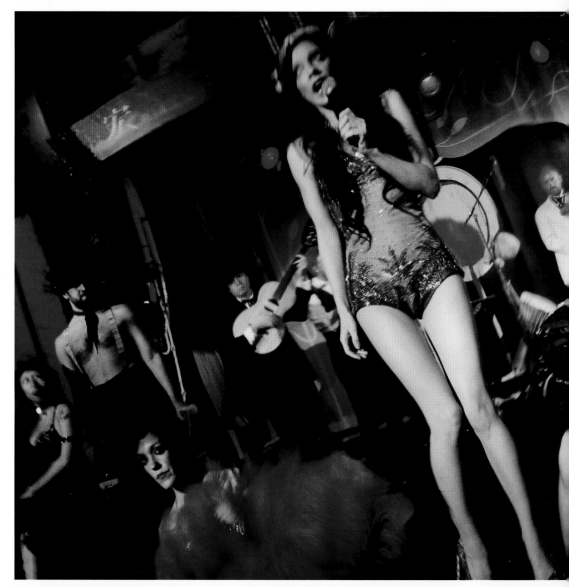

The Citizens Band

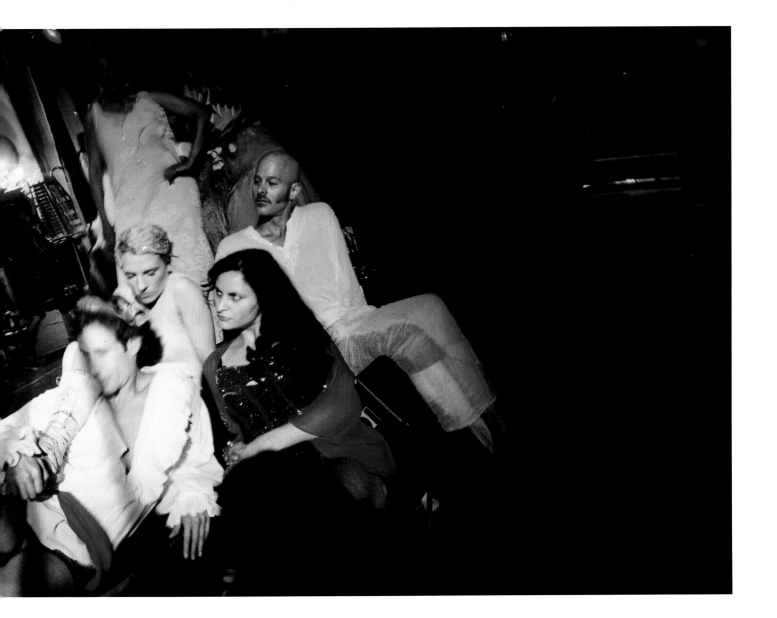

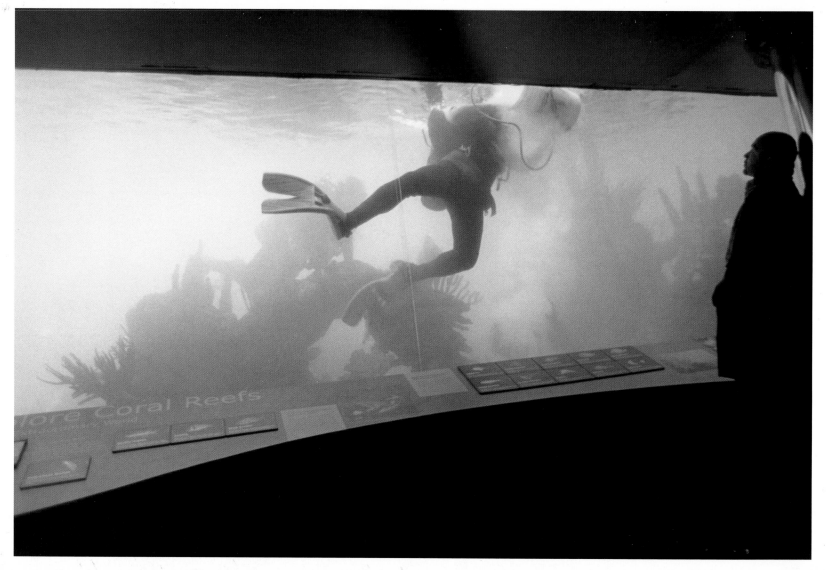

Above: An unusual sea mammal at the New York Aquarium, Coney Island, Brooklyn. Opposite: Steve Quinn's diorama-drawing class at the American Museum of Natural History

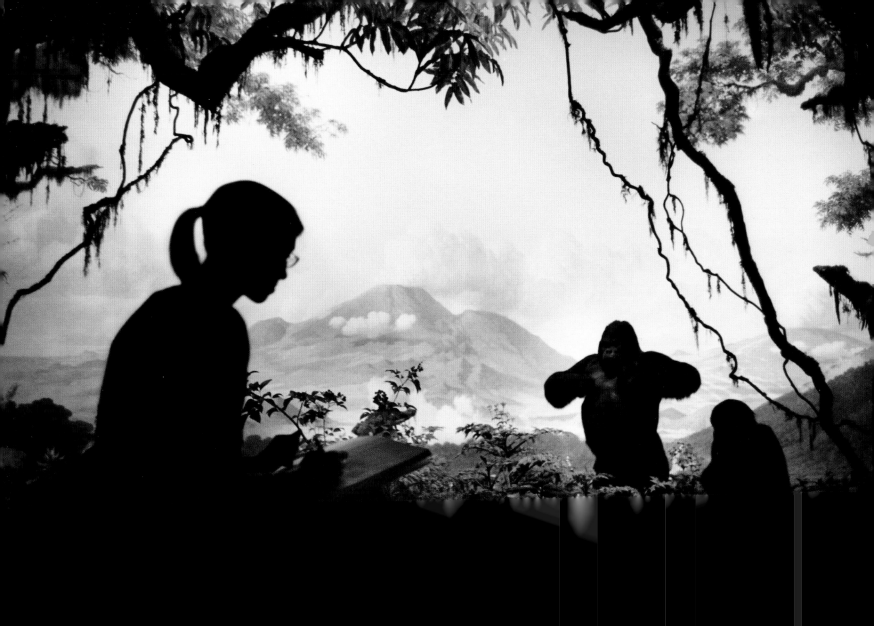

AFTERWORD BY ELISABETH BIONDI

"I am exhausted," Sylvia says to me right after one of The New Yorker's weekly Goings On About Town shoots. Although she works much as a dancer does—crouching on the floor, bending her agile body, and leaping up to catch her subject from another angle, even with her camera pulling her down to earth—this is not the reason for her exhaustion. Sylvia is exhausted because she engages all of herself when she takes pictures: her entire being, her soul as well as her body.

I met Sylvia Plachy and began working with her almost twenty years ago. Rarely have I encountered photographs of such value that so completely reflect the personality of the photographer. A Hungarian forced to leave home with her family when she was thirteen, she has never lost touch with the slightly Surrealist tradition of Hungarian photography: melancholy mixed with a bit of humor and much empathy. She shared this vision with her friend and mentor André Kertész.

Sylvia describes her pictures as "visions trapped in the lens of [her] camera, unable to escape." Like Sylvia herself, her photographs are open, spirited, and full of life. They are impressionistic and allow us freedom to wander and associate, to fill in the blanks, to experience the images in our own way.

Sylvia is curious and compassionate, and the people she photographs intuitively trust her genuine desire to know more about them. This journalistic curiosity combines with a more or less subconscious and artistic approach, making her pictures at once informative and lyrical. Place and time often suffice as captions as she documents—and more important, captures—experience.

Her pictures are as close to poetry as they are to the world of hard facts. They have wit and humanity; they honor memory and evoke dreams. So does Sylvia, and more so with every passing year.

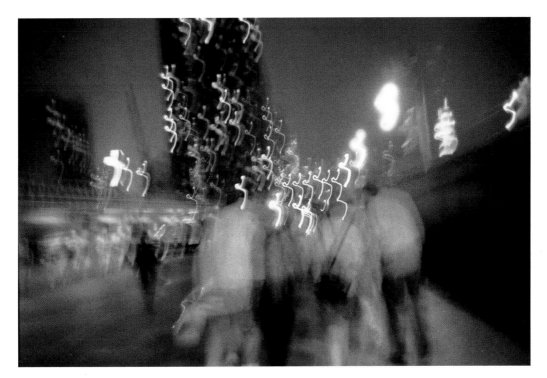

End of the night

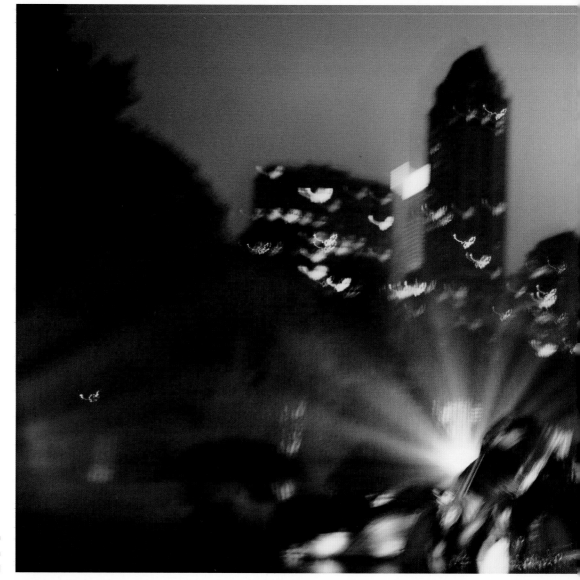

Pierre Huyghe shooting the film
A Journey That Wasn't, later shown
at the Whitney Biennial

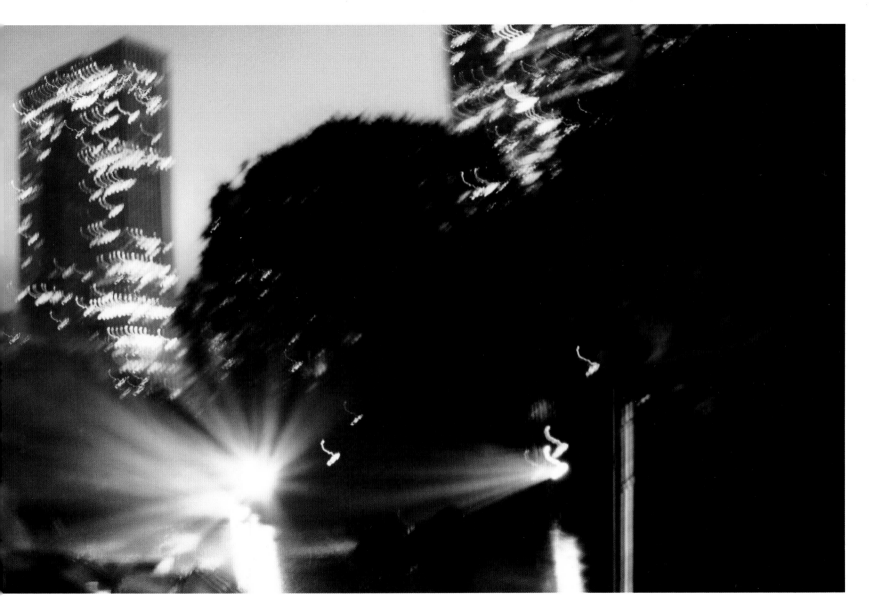

ACKNOWLEDGMENTS

It may not be true, as my father used to promise, that you'll find gold on the pavement, but there is always the promise of glitter.

There is no better place on a good day than New York City. Step out and chase your dreams. At first you may be lost or bored, but soon you'll find meaning: there will be adventure, perhaps companionship, serendipity, and even camel poop on occasion. If you bring a camera, you might turn some of these moments into photographs. And if you are really lucky, a few of them will be published in *The New Yorker*.

I want to thank Elisabeth Biondi, Caroline Mailhot, Pamela McCarthy, and, of course, David Remnick for my dream job at *The New Yorker*. I've had a really good run: a picture a week in Goings On About Town for more than a year. I would especially like to thank Elisabeth, whom I've known for years. She not only sent me off on each assignment with thoughtful advice, but gave me a wide berth and still had such kind words of farewell for me at the end of this book. And where would I have been without the gentle prodding of Elizabeth Culbert, who made sure that everyone—messengers, interns, labs, press agents, subjects/stars, and, of course, the photographer—showed up and delivered on time.

That these photographs, originally taken for *The New Yorker*, have another life between the covers of this book is thanks to the enthusiasm of Melissa Harris; I'm so glad she made me do it. I am also grateful to my other friends, Sid Kaplan and Jen Petreshock, both excellent printers (of black-and-white work and of color, respectively), who did their magic as always, and made me look good. A big thank you to Mark Singer, my buddy from our long association on *The New Yorker*'s U.S. Journal column, for his charming, funny, and generous foreword. And thanks, finally, to Yolanda Cuomo and her assistant, Kristi Norgaard: they are two big reasons that I like to do books. Yo—a kind of little sister—has a sure and keen sense of design, and Kristi is brilliant at making it all happen on the computer. When I'm in their studio, all is well.

I dedicate this book to the city, to my friends and the cats, and, most of all, to Elliot and Adrien.

Front cover: Stars of the *Radio City Christmas Spectacular*
Back cover: A table at the filming of Julie Taymor's *Across the Universe*
Frontispiece: Quebec's Cirque Éloize at the New Jersey Performing Arts Center, Newark

Editor: Melissa Harris
Book Design: Yolanda Cuomo, NYC
Associate Designer: Kristi Norgaard
Copy Editor: Diana C. Stoll
Production: Sarah Henry

The staff for this book at Aperture Foundation includes: Ellen S. Harris, *Chief Executive Officer*; Michael Culoso, *Director of Finance and Administration*; Lesley A. Martin, *Executive Editor, Books*; Nancy Grubb, *Executive Managing Editor, Books*; Susan Ciccotti, *Production Editor*; Matthew Pimm, *Production Director*; Andrea Smith, *Director of Communications*; Kristian Orozco, *Director of Sales and Foreign Rights*; Diana Edkins, *Director of Exhibitions and Limited-Edition Photographs*; Laura Cooke and Yass Etemadi, *Work Scholars*

First edition
Printed and bound by Mariogros in Italy
10 9 8 7 6 5 4 3 2 1

SYLVIA PLACHY was born in 1943 in Budapest. Her photo-essays and portraits have appeared in the *New York Times Magazine*, the *Village Voice*, *Granta*, *Artforum*, and *Fortune*, and have been exhibited around the world. Her previous books with Aperture include *Self Portrait with Cows Going Home* (2004), which won a Golden Light award for best book, and *Unguided Tour* (1990), which received an International Center of Photography Infinity Award.

Library of Congress Control Number: 2007921839
ISBN 978-1-59711-051-8

Aperture Foundation books are available in North America through:
D.A.P./Distributed Art Publishers
155 Sixth Avenue, 2nd Floor
New York, N.Y. 10013
Phone: (212) 627-1999 Fax: (212) 627-9484

Aperture Foundation books are distributed outside North America by:
Thames & Hudson
181A High Holborn
London WC1V 7QX
United Kingdom
Phone: + 44 20 7845 5000 Fax: + 44 20 7845 5055
Email: sales@thameshudson.co.uk

Co-published with **THE NEW YORKER**

aperturefoundation

547 West 27th Street
New York, N.Y. 10001
www.aperture.org

The purpose of Aperture Foundation, a non-profit organization, is to advance photography in all its forms and to foster the exchange of ideas among audiences worldwide.

MARK SINGER has been a staff writer at *The New Yorker* since 1974. His most recent books, *Somewhere in America* (2004) and *Character Studies* (2005), are collections of pieces that originally appeared in *The New Yorker*.

ELISABETH BIONDI has been visuals editor of *The New York* since 1996. Previously, she was the director of photography at *Stern* and *Vanity Fair* and picture editor at *GEO USA*.